PACKAGING

ROCKPORT
PUBLISHERS

ROCKPORT PUBLISHERS, INC.
ROCKPORT, MASSACHUSETTS

FIRST PUBLISHED IN THE UNITED STATES OF AMERICA BY:
ROCKPORT PUBLISHERS, INC.
146 GRANITE STREET
ROCKPORT, MASSACHUSETTS 01966
TELEPHONE: (508) 546-9590
FAX: (508) 546-7141

OTHER DISTRIBUTION BY:
ROCKPORT PUBLISHERS, INC.
ROCKPORT, MASSACHUSETTS 01966

COVER CONTRIBUTORS:
(CLOCKWISE FROM THE TOP LEFT)
LIPSON-ALPORT-GLASS ASSOCIATES.
SUPON DESIGN GROUP
HORNALL ANDERSON DESIGN WORKS
RED HERRING DESIGN
PRIMO ANGELI
NEWELL AND SORRELL LTD.

ISBN 1-56496-158-3

10 9 8 7 6 5 4 3

PRINTED IN HONG KONG

INTRODUCTION

GIVING A NEW PRODUCT A COMPETITIVE EDGE HAS BECOME MORE AND MORE DIFFICULT OVER THE PAST FEW YEARS. THE MARKETPLACE IS OVERWHELMED BY AN AVALANCHE OF SIMILAR PRODUCTS—SOME WITH THEIR OWN UNIQUE MERITS, BUT MOST BASICALLY ALIKE. THANKFULLY, THE MANUFACTURING WORLD HAS CREATED SOMETHING CALLED PACKAGE DESIGN, WITHOUT WHICH WE WOULD BE UNABLE TO TELL ONE JAR OF PEANUT BUTTER FROM THE NEXT.

THE CHALLENGE GRAPHIC DESIGNERS FACE NOW IS CREATING PACKAGES THAT INFLUENCE CONSUMERS TO BUY THIS PRODUCT OVER THE MANY HUNDREDS JUST LIKE IT. HOW THIS CHALLENGE IS MET CAN MAKE OR BREAK THE SUCCESS OF THE PRODUCT ITSELF.

THIS VOLUME OF THE *DESIGN LIBRARY* SERIES FEATURES THE BEST AND MOST INNOVATIVE PACKAGES DESIGNED IN THE PAST DECADE. THESE DESIGNS ENTICE, APPEAL, INTRIGUE AND EXCITE; THESE ARE THE DESIGNS THAT SELL PRODUCTS. THE DESIGNERS PRESENTED IN THESE PAGES UNDERSTAND NOT ONLY DESIGN, THEY UNDERSTAND THE PRODUCT AND THE MARKET AS WELL.

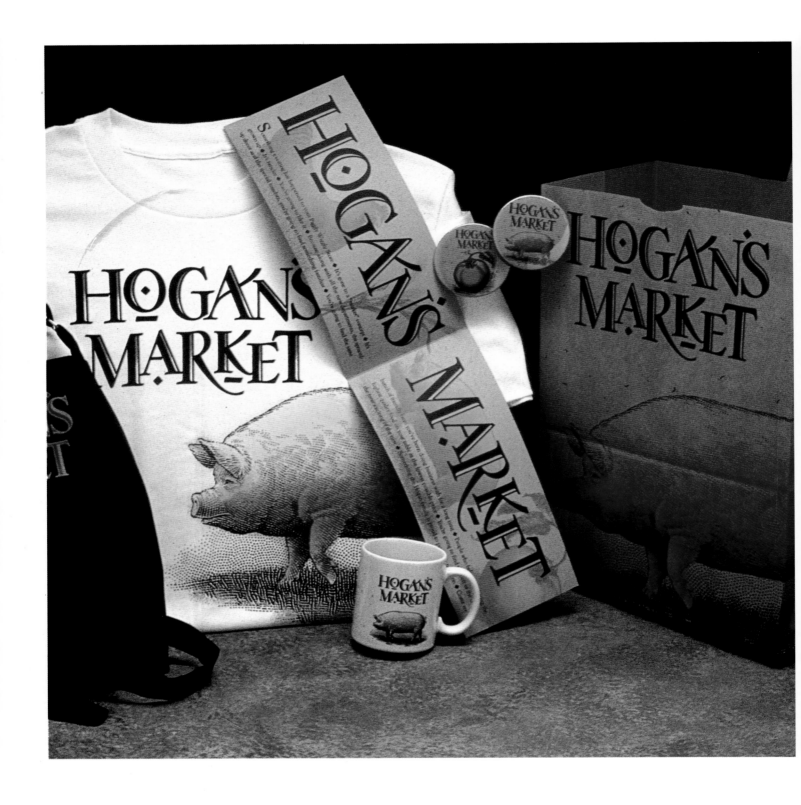

Hogans Market
Puget Sound Marketing
Design Firm, Hornall Anderson
Design Works;
Art Directors, Jack Anderson,
Julia Lapine;
Designers, Julia Lapine, Denise
Weir, Lian Ng;
Illustrator, Larry Jost;
Hand Lettering, Nancy Stenz

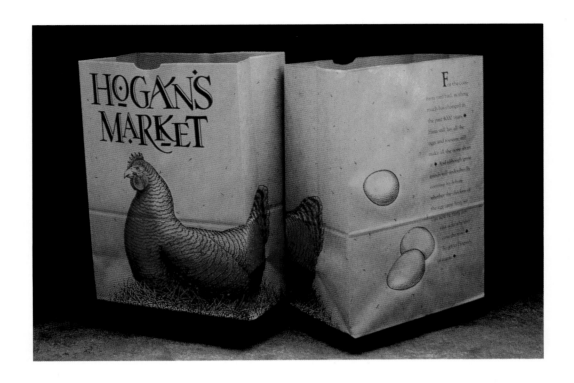

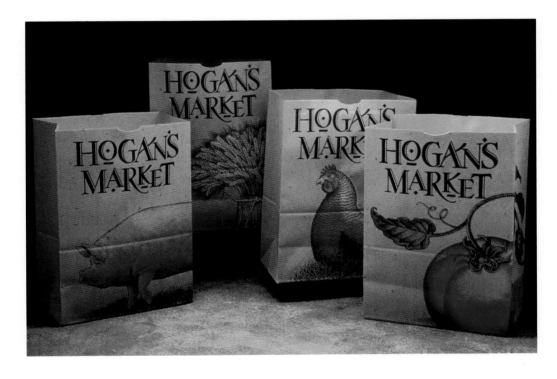

K2 Skies
K2 Corp
Design Firm, Hornall
Anderson Design Works;
Art Director, Jack
Anderson;
Designers, Jack
Anderson, Jani Drewfs,
David Bates

K2 Goggle Packaging
K2 Corp
Design Firm, Hornall
Anderson Design Works;
Art Director, Jack
Anderson;
Designers, Jack Anderson,
David Bates, Mike Courtney

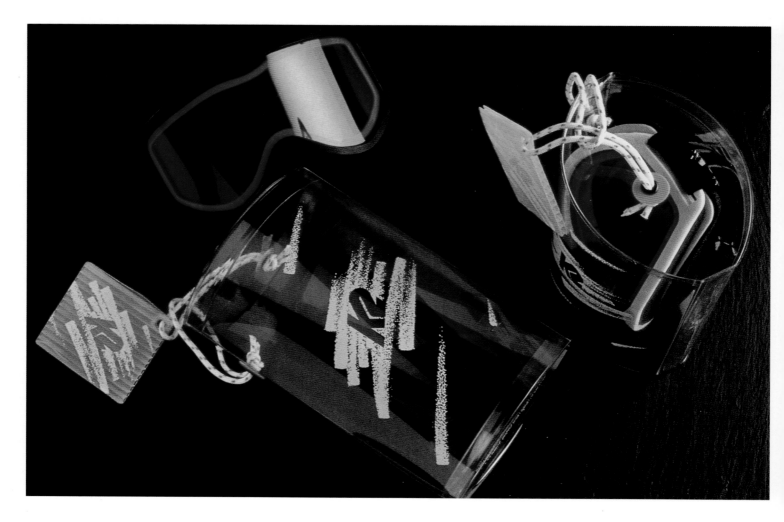

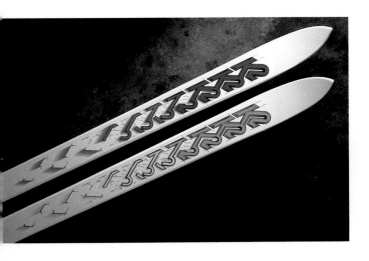

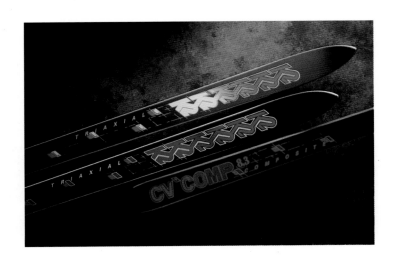

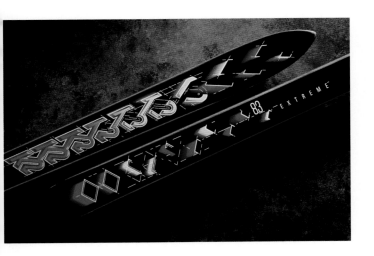

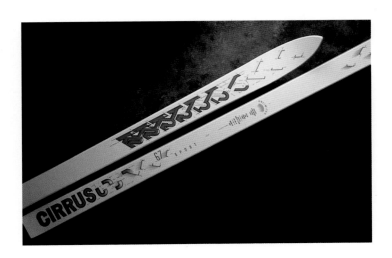

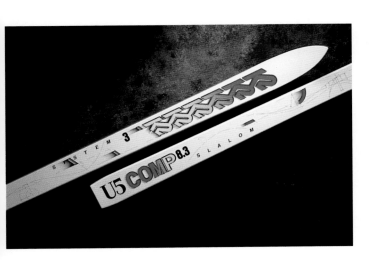

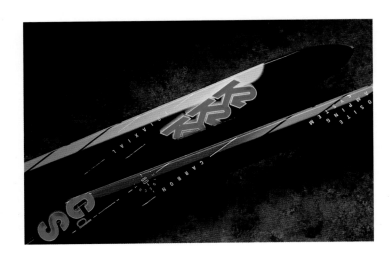

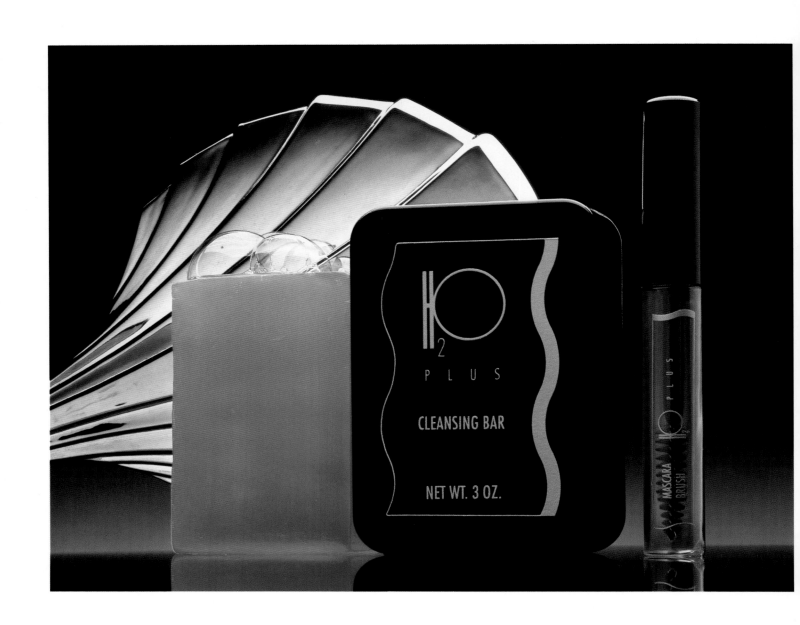

H2O Healthcare Products
J.M. Holdings
Design Firm, Murrie, White,
Drummond, Lienhart;
Art Director/Designer,
James Lienhart;
Photographer, Paul Rung

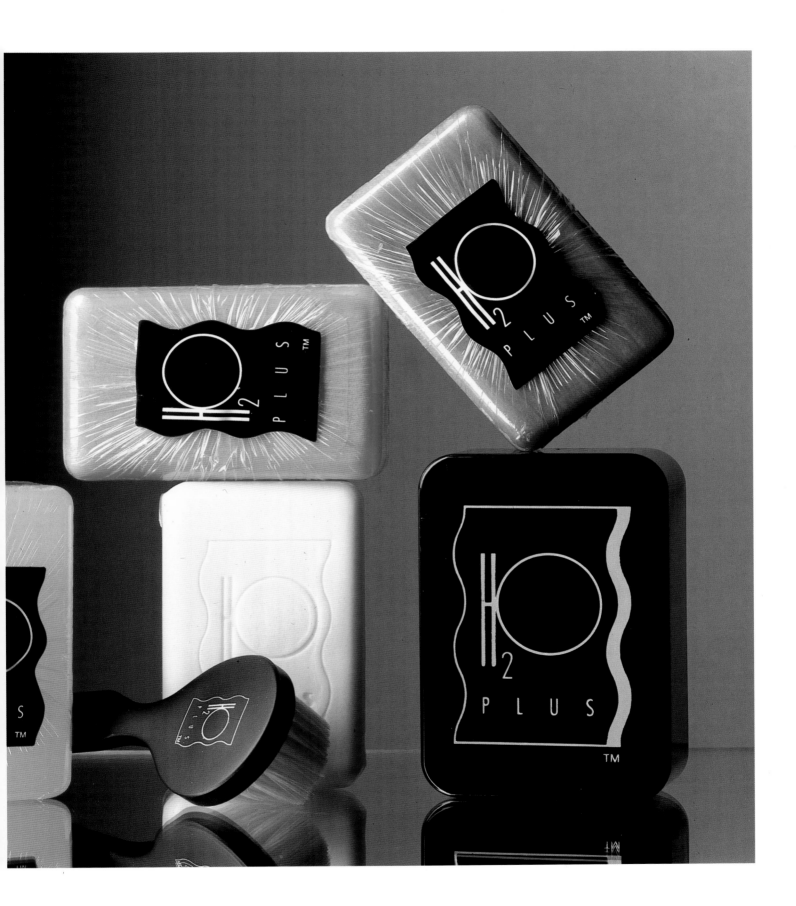

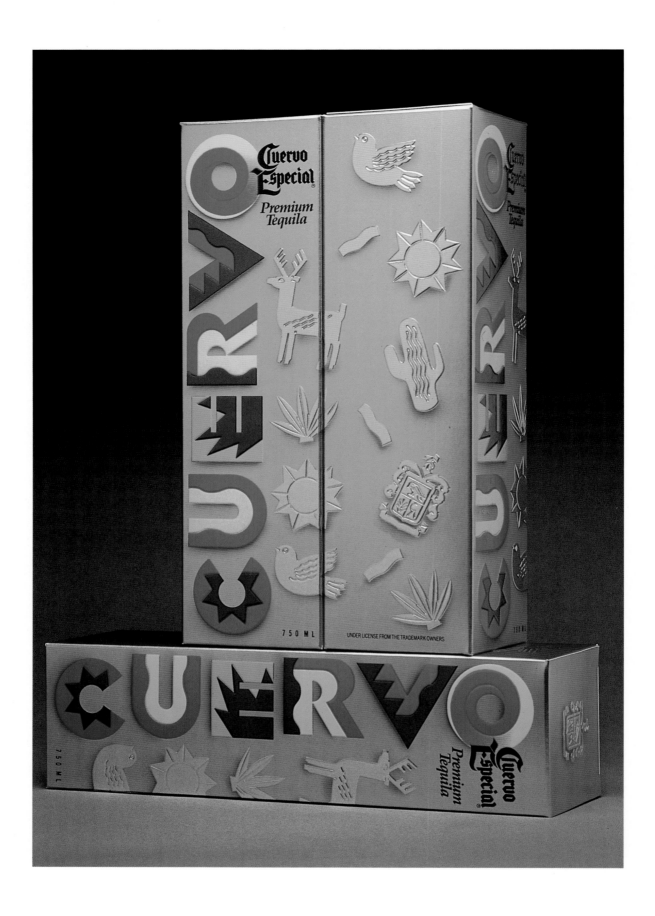

CUERVO GIFT CARTON
HEUBLEIN INC.
**DESIGN FIRM, MITTLEMAN-
ROBINSON INC;
ART DIRECTOR, FRED MITTLEMAN;
DESIGNER, RICHARD BRANDT**

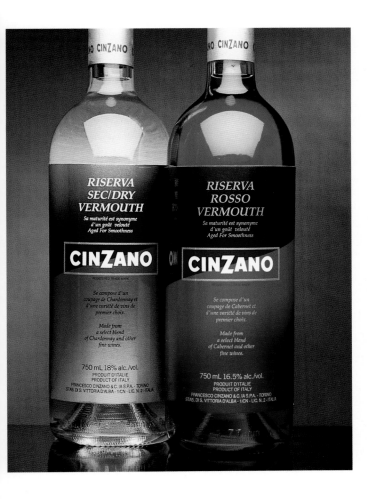

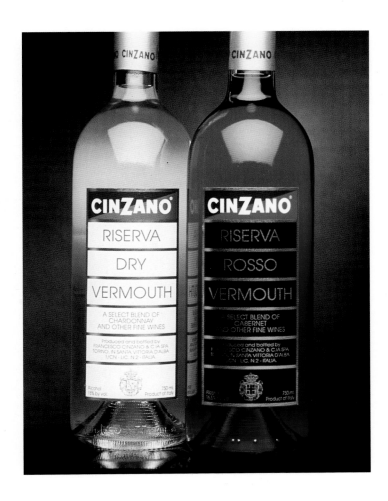

CINZANO VERMOUTH
PADDINGTON
**DESIGN FIRM, MITTLEMAN-ROBINSON INC;
ART DIRECTOR/DESIGNER, FRED MITTLEMAN**

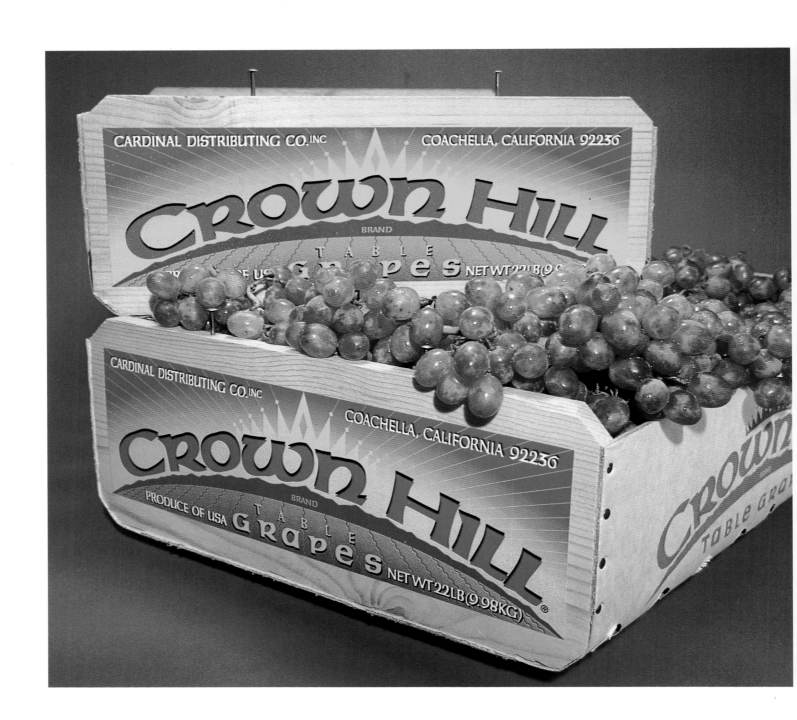

CROWN HILL GRAPES
CARDINAL DISTRIBUTING CO.
DESIGN FIRM, MARK PALMER DESIGN CO;
ART DIRECTOR/DESIGNER, MARK PALMER;
COMPUTER PRODUCTION, CURTIS PALMER

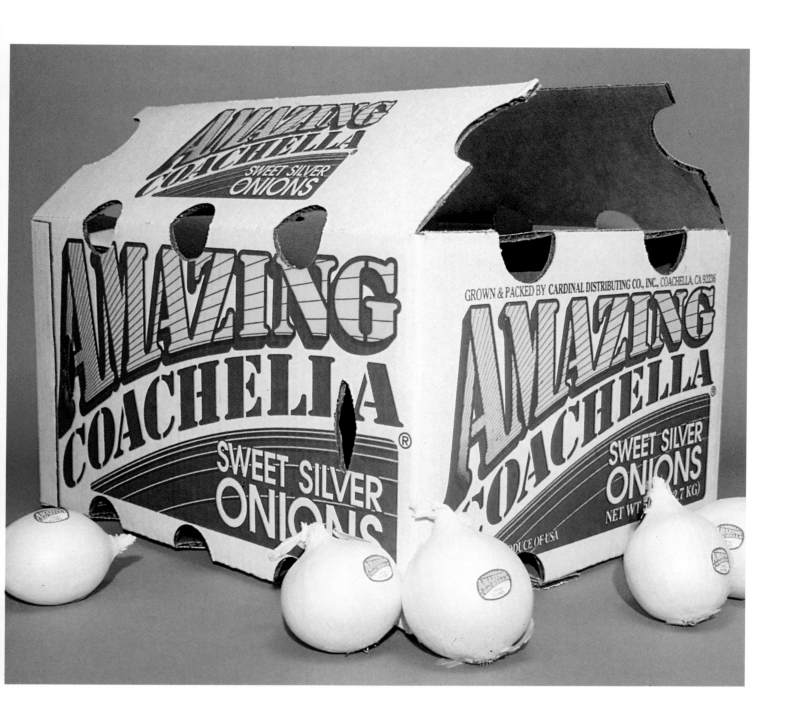

Amazing Coachella Onion Box
Cardinal Distributing Co.
**Design Firm, Mark Palmer Design Co.;
Art Director/Designer, Mark Palmer;
Computer Production, Curtis Palmer**

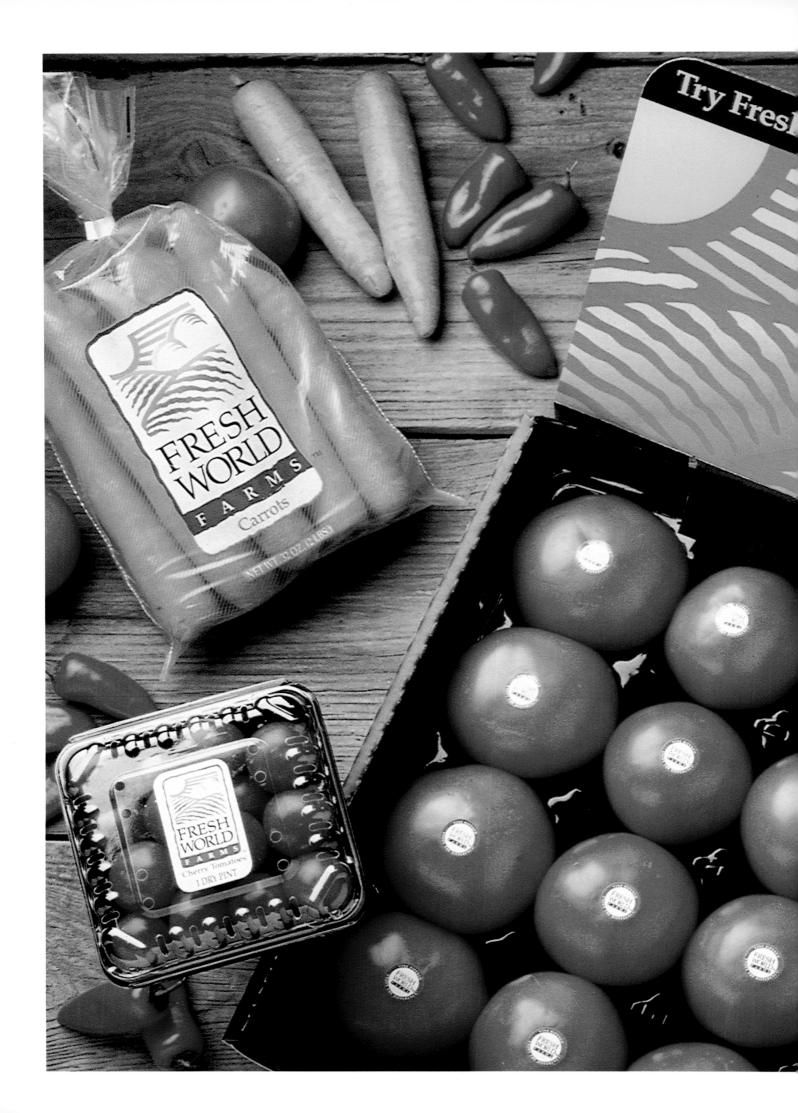

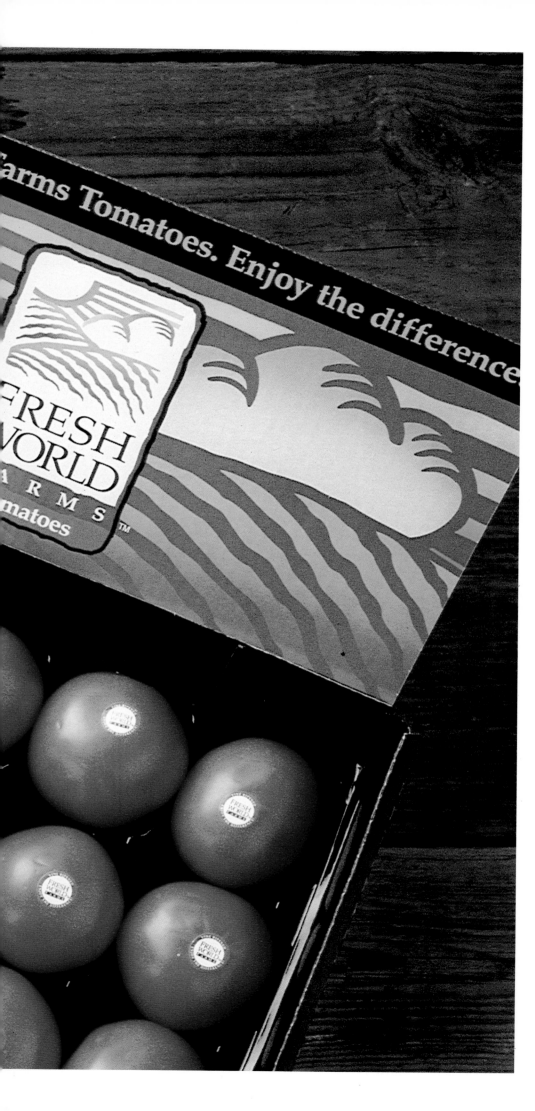

Fresh World Farms Tomatoes
Fresh World Farms
DESIGN FIRM, BAILEYSPIKER, INC.;
ART DIRECTOR, PAUL SPIKER/DAVE FIEDLER;
DESIGNER, STEVE PERRY;
ILLUSTRATOR, STEVE PERRY

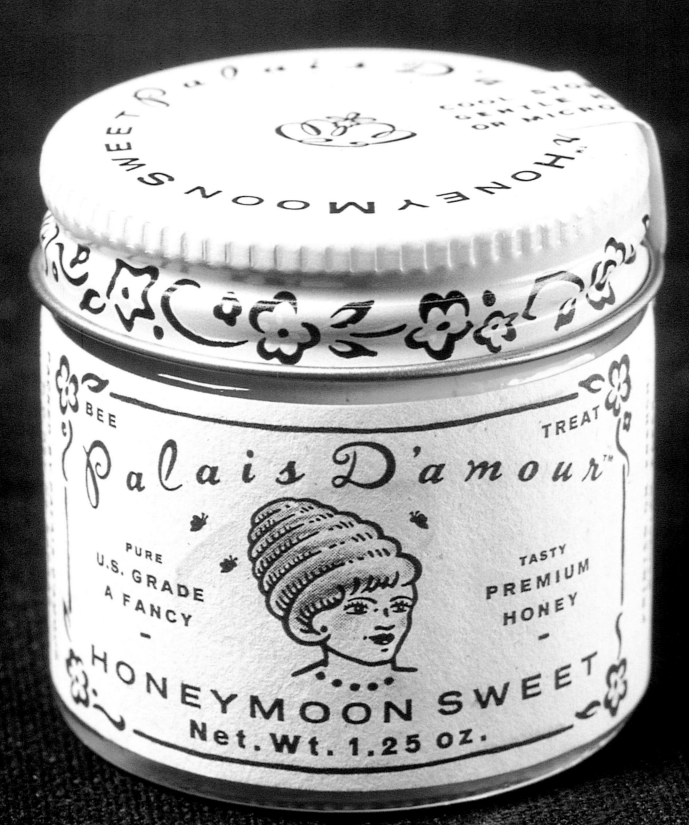

ALAIS D'AMOUR HONEYMOON SWEET
ALAIS D'AMOUR
ESIGN FIRM, OLSON JOHNSON DESIGN CO.;
RT DIRECTOR, HALEY JOHNSON;
ESIGNER, HALEY JOHNSON;
LUSTRATOR, HALEY JOHNSON

INTERNATIONAL COFFEES ANNUAL
COLLECTIBLE TINS SERIES
KRAFT GENERAL FOODS
DESIGN FIRM, MITTLEMAN/
ROBINSON, INC.;
ART DIRECTOR, PAM ROBINSON

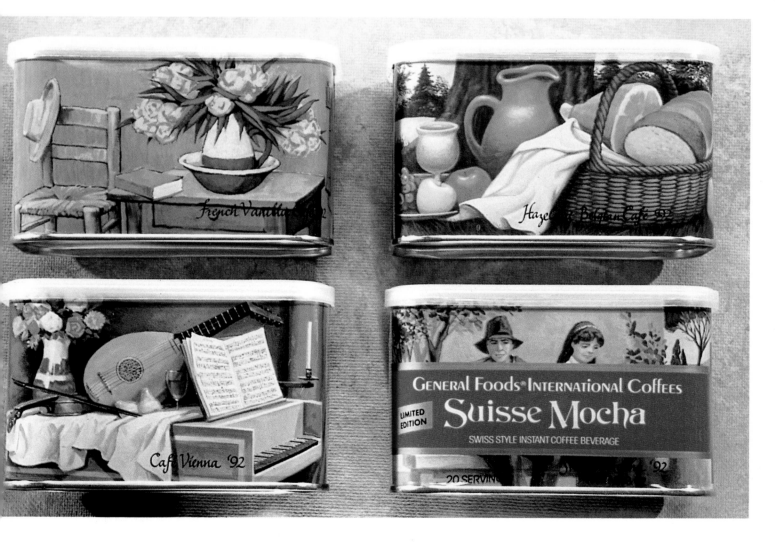

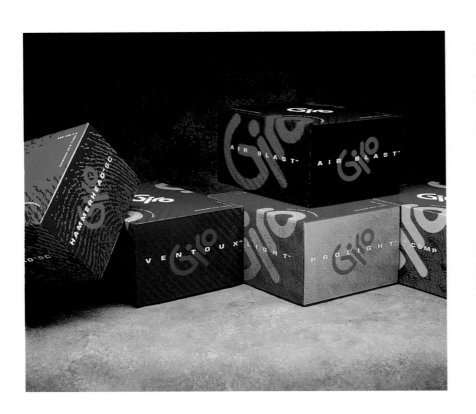

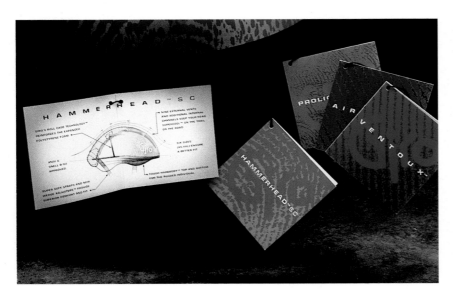

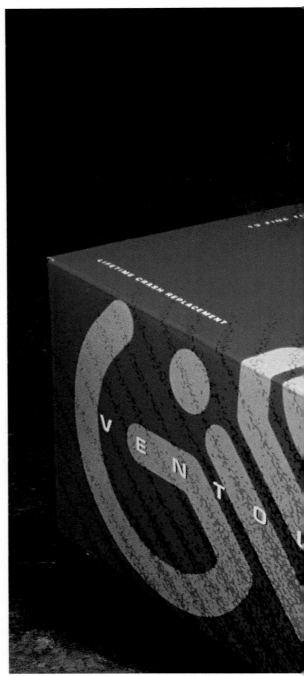

GIRO 1992 HELMETS PACKAGING
GIRO SPORTS DESIGN, INC.
DESIGN FIRM, HORNALL ANDERSON DESIGN WORKS;
ART DIRECTOR, JACK ANDERSON;
DESIGNERS, JACK ANDERSON, DAVID BATES, LIAN NG

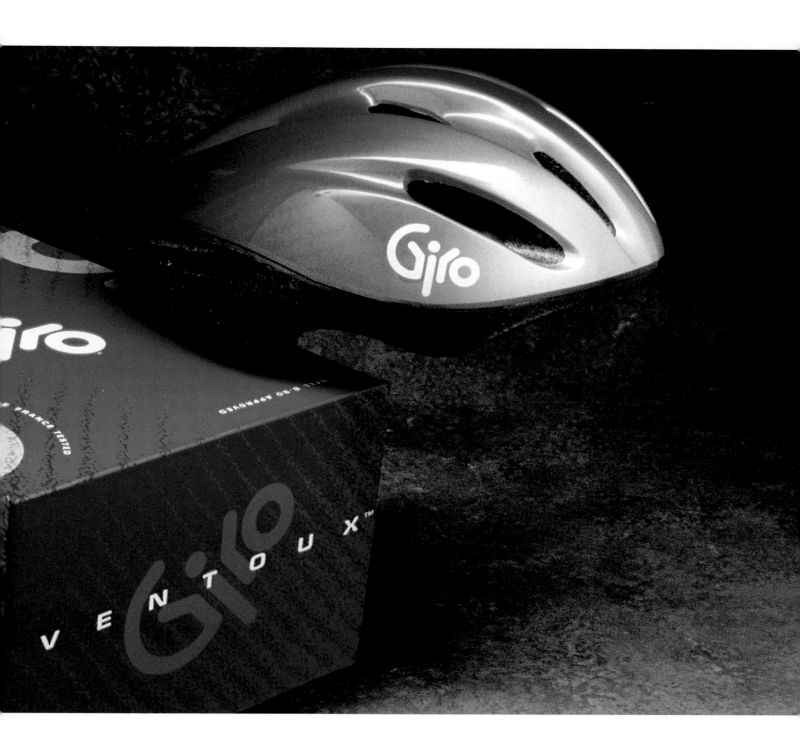

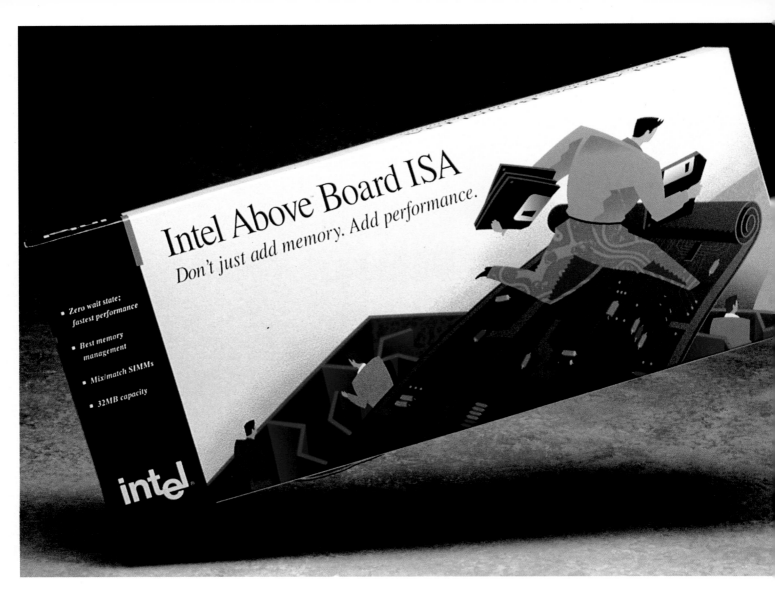

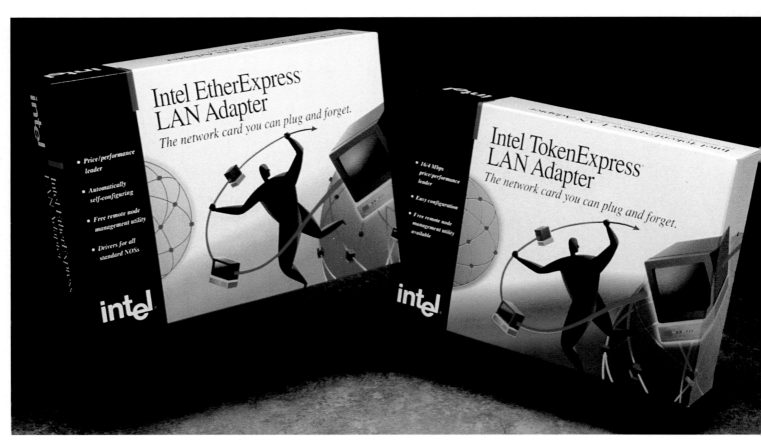

INTEL PACKAGING SERIES
INTEL CORPORATION
DESIGN FIRM, HORNALL ANDERSON DESIGN WORKS;
ART DIRECTOR, JACK ANDERSON, JULIA LAPINE;
DESIGNERS, JACK ANDERSON, JULIA LAPINE,
HEIDI HATLESTAD, BRUCE BRANSON-MEYER,
LESLIE MacINNES, DAVE BATES, LIAN NG;
ILLUSTRATOR, DON BAKER, MICK WIGGINS

LEVI'S GIRLS LABELING
LEVI STRAUSS & CO.
DESIGN FIRM, MORLA DESIGN;
ART DIRECTOR, JENNIFER MORLA;
DESIGNERS, JENNIFER MORLA,
JEANETTE ARAMBURU;
PHOTOGRAPHER, BYBEE STUDIOS

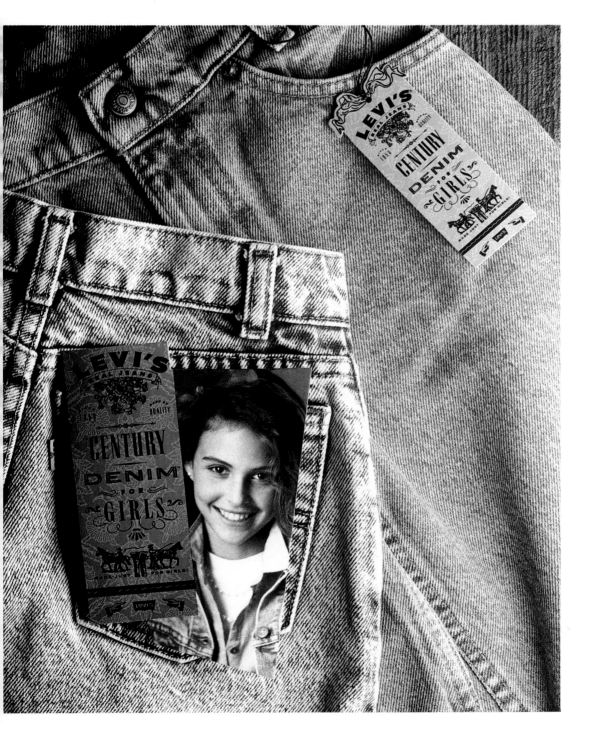

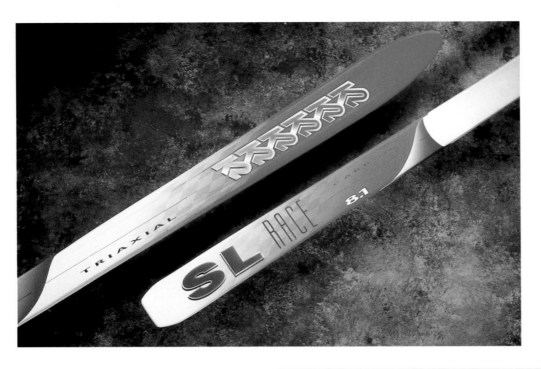

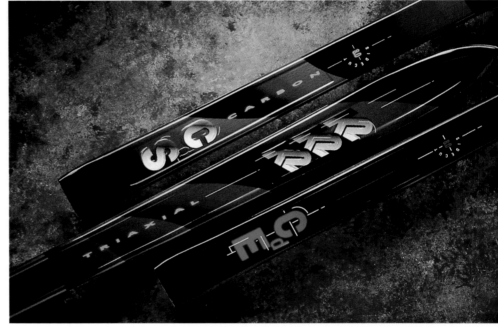

K2 Skis
K2 Corporation
Design Firm, Hornall Anderson
Design Works;
Art Director, Jack Anderson;
Designers, Jack Anderson, Mary
Hermes, David Bates, Brian O'Neill,
Julie Tanagi-Lock

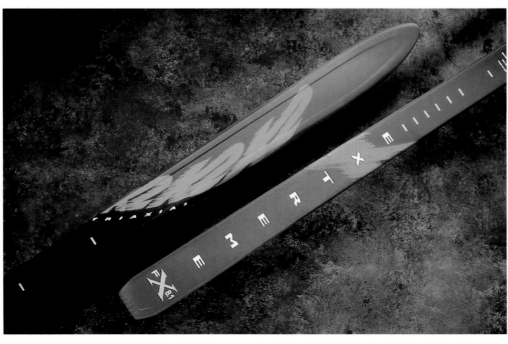

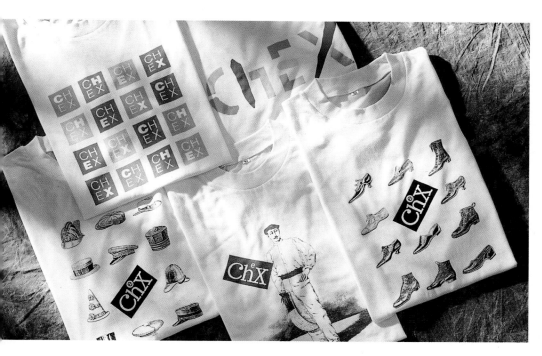

CHEX INTERNATIONAL SALES LIMITED
LABEL & SHOPPING BAG
CHEX INTERNATIONAL SALES LIMITED
**DESIGN FIRM, KAN TAI-KEUNG DESIGN &
ASSOCIATES LTD.;
CREATIVE DIRECTOR, KAN TAI-KEUNG;
ART DIRECTOR, FREEMAN LAU SIU HONG;
DESIGNER, FREEMAN LAU SIU HONG**

CENTURY CLUB
NATIONAL TRAVELERS LIFE
**DESIGN FIRM, SAYLES GRAPHIC
DESIGN;
ART DIRECTOR, JOHN SAYLES;
DESIGNER, JOHN SAYLES;
ILLUSTRATOR, JOHN SAYLES**

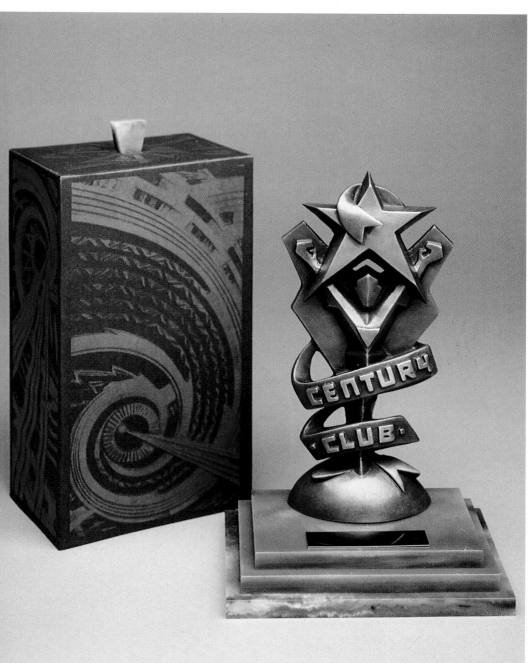

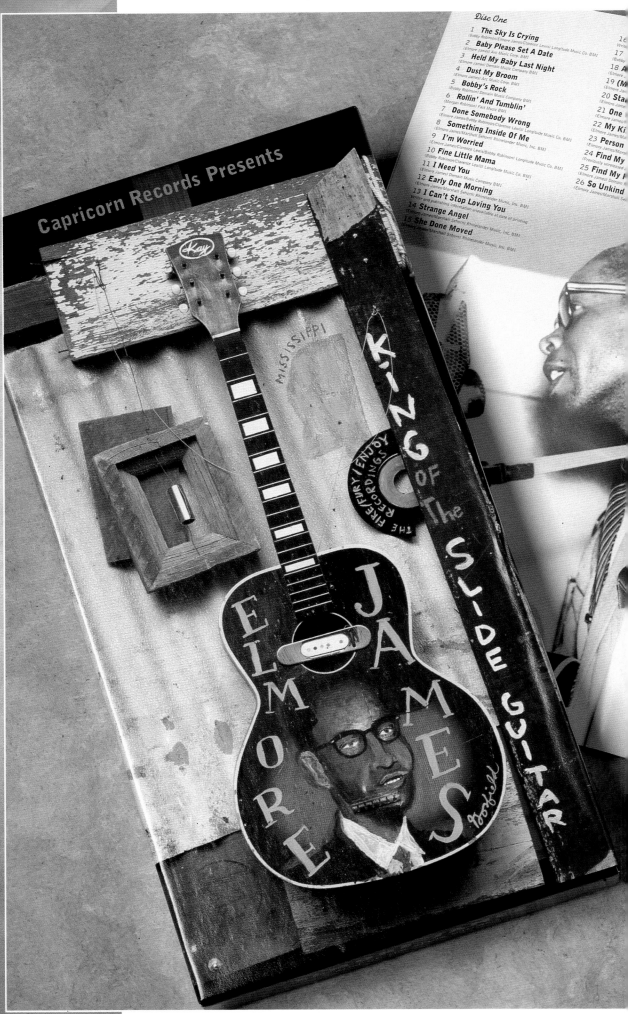

KING OF THE SLIDE GUITAR
ELMORE JAMES
CAPRICORN RECORDS
DESIGN FIRM, WARNER
BROTHERS RECORDS
(IN-HOUSE);
ART DIRECTOR/DESIGNER,
KIM CHAMPAGNE;
BOOKLET DESIGN,
KIM CHAMPAGNE,
MIKE DIEHL;
ILLUSTRATOR,
JOSH GOSHFIELD;
PHOTOGRAPHER,
GEORGE ADINS

Capricorn Records Presents

Disc One

1 **The Sky Is Crying**
(Bobby Robinson/Elmore James/Clarence Lewis) Longitude Music Co. BMI
2 **Baby Please Set A Date**
(Elmore James) Arc Music Corp. BMI
3 **Held My Baby Last Night**
(Elmore James) Demain Music Company BMI
4 **Dust My Broom**
(Elmore James) Arc Music Corp. BMI
5 **Bobby's Rock**
(Bobby Robinson) Demain Music Company BMI
6 **Rollin' And Tumblin'**
(Morgan Robinson) Fast Music BMI
7 **Done Somebody Wrong**
(Elmore James/Bobby Robinson/Clarence Lewis) Longitude Music Co. BMI
8 **Something Inside Of Me**
(Elmore James/Marshall Sehorn) Rhinelander Music, Inc. BMI
9 **I'm Worried**
(Elmore James/Clarence Lewis/Bobby Robinson) Longitude Music Co. BMI
10 **Fine Little Mama**
(Bobby Robinson/Clarence Lewis) Longitude Music Co. BMI
11 **I Need You**
(Elmore James) Demain Music Company BMI
12 **Early One Morning**
(Elmore James/Marshall Sehorn) Rhinelander Music, Inc. BMI
13 **I Can't Stop Loving You**
Writer and publishing information unavailable at date of printing
14 **Strange Angel**
(Elmore James/Marshall Sehorn) Rhinelander Music, Inc. BMI
15 **She Done Moved**
(Elmore James/Marshall Sehorn) Rhinelander Music, Inc. BMI

16
Write
17
(Bobby
18 **A**
(Elmore
19 **(M**
(Elmore
20 **Sta**
(Elmore
21 **One**
(Elmore
22 **My Ki**
(Elmore
23 **Person**
(Elmore
24 **Find My**
(Previously unrelea
25 **Find My F**
(Elmore James/Demain
26 **So Unkind**
(Elmore James/Marshall Se

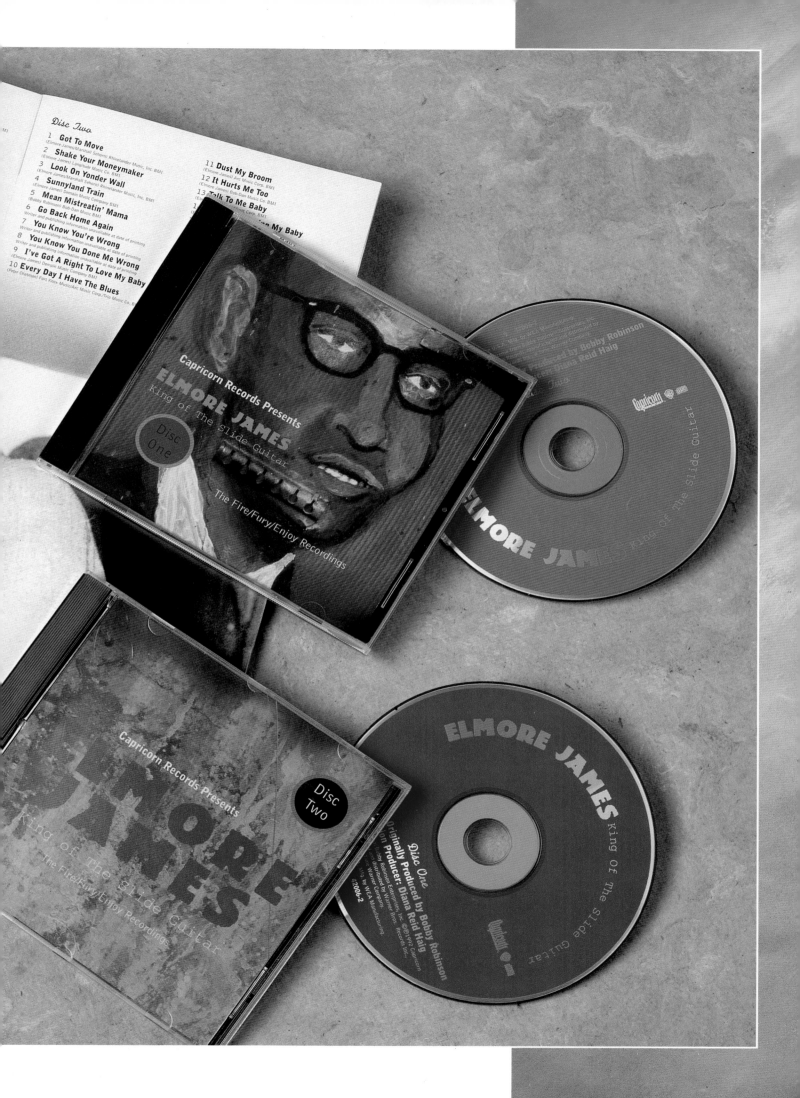

KING OF THE BLUES
B.B. KING
MCA RECORDS
DESIGN FIRM, CIMARRON,
BACON, O'BRIEN;
ART DIRECTOR, VARTAN;
DESIGNER, JOHN O'BRIEN

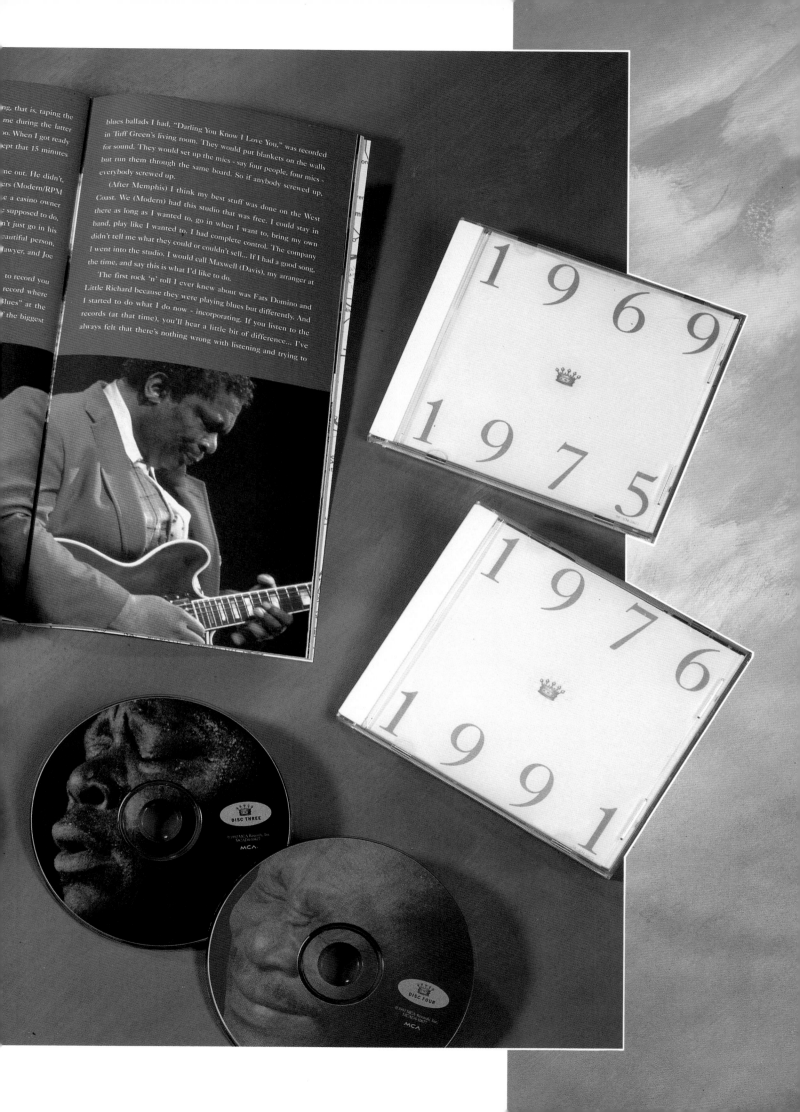

ng, that is, taping the
me during the latter
o. When I got ready
ept that 15 minutes

ne out. He didn't,
rs (Modern/RPM
e a casino owner
e supposed to do.
n't just go in his
eautiful person,
awyer, and Joe

to record you
record where
Blues" at the
f the biggest

blues ballads I had, "Darling You Know I Love You," was recorded
in Tuff Green's living room. They would put blankets on the walls
for sound. They would set up the mics - say four people, four mics -
but run them through the same board. So if anybody screwed up,
everybody screwed up.

(After Memphis) I think my best stuff was done on the West
Coast. We (Modern) had this studio that was free. I could stay in
there as long as I wanted to, go in when I want to, bring my own
band, play like I wanted to. I had complete control. The company
didn't tell me what they could or couldn't sell... If I had a good song,
I went into the studio. I would call Maxwell (Davis), my arranger at
the time, and say this is what I'd like to do.

The first rock 'n' roll I ever knew about was Fats Domino and
Little Richard because they were playing blues but differently. And
I started to do what I do now - incorporating. If you listen to the
records (at that time), you'll hear a little bit of difference... I've
always felt that there's nothing wrong with listening and trying to

SNAKE BITE LOVE
ZACHARY RICHARD
A & M RECORDS
**DESIGN FIRM, A & M
RECORDS GRAPHICS;
ART DIRECTOR,
CHUCK BEESON;
DESIGNERS, CHUCK
BEESON, REBECCA
CHAMLEE;
PHOTOGRAPHER,
CAROLINE GREYSHOCK**

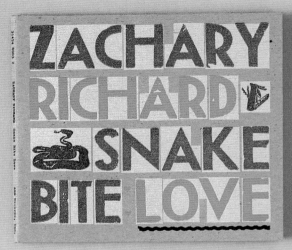

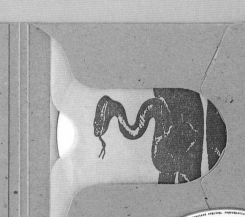

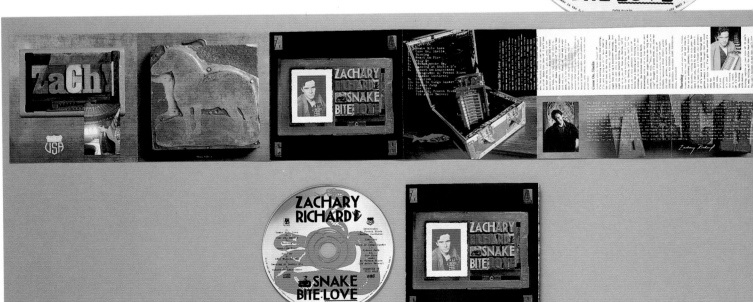

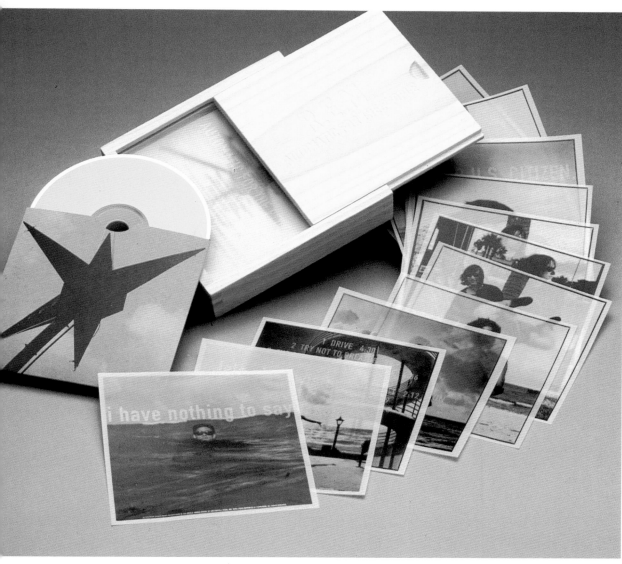

AUTOMATIC FOR THE PEOPLE
(PROMOTIONAL BOX)
R.E.M.
WARNER BROTHERS RECORDS
DESIGN FIRM, WARNER
BROTHERS RECORDS
(IN-HOUSE);
ART DIRECTOR/DESIGNER,
TOM RECCHION, MICHAEL
STIPE;
COMPUTER IMAGING, CECIL
JUANARENA, INSIGHT
COMMUNICATIONS;
PHOTOGRAPHER, ANTON
CORBIJN, FREDRIK NILSEN

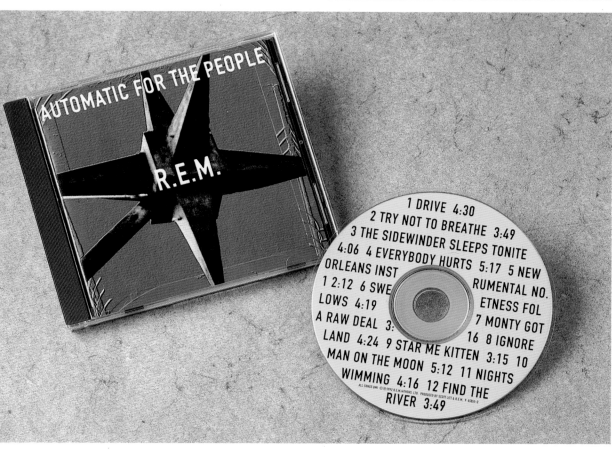

AUTOMATIC FOR THE PEOPLE
R.E.M.
WARNER BROTHERS RECORDS
DESIGN FIRM, WARNER
BROTHERS RECORDS
(IN-HOUSE);
ART DIRECTOR, TOM
RECCHION, MICHAEL STIPE,
JEFF GOLD, JIM LADWIG
DESIGNERS, TOM RECCHION,
MICHAEL STIPE;
PHOTOGRAPHER,
ANTON CORBIJN

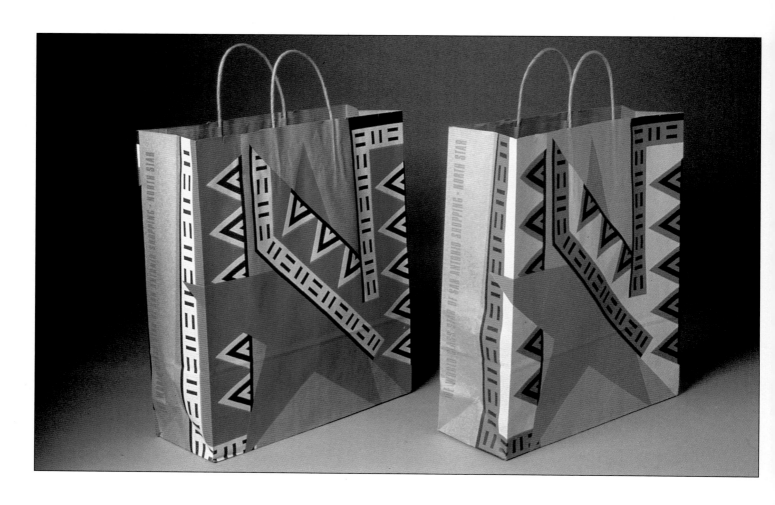

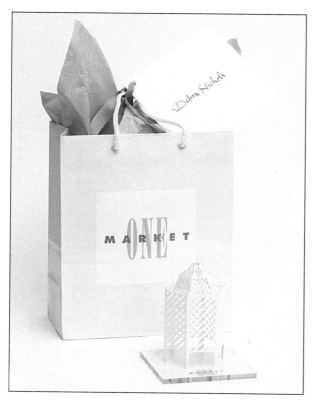

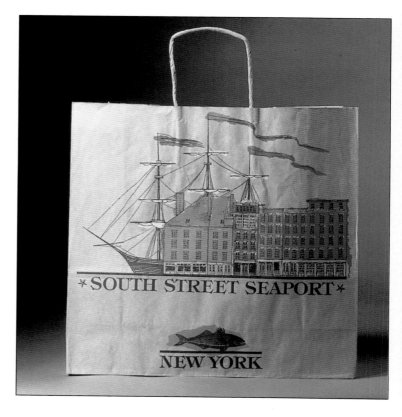

TOP
THE ROUSE COMPANY
DESIGN FIRM, SULLIVANPERKINS;
ART DIRECTOR, RON SULLIVAN;
DESIGNERS, CLARK RICHARDSON, LINDA HELTON;
ILLUSTRATOR/ARTIST, CLARK RICHARDSON, LINDA HELTON

ABOVE LEFT
ONE MARKET ASSOCIATION
CB COMMERCIAL REAL ESTATE
DESIGN FIRM, DEBRA NICHOLS DESIGN;
ART DIRECTOR, DEBRA NICHOLS;
DESIGNERS, DEBRA NICHOLS, ROXANNE MALEK

ABOVE RIGHT
THE ROUSE COMPANY
DESIGN FIRM, SULLIVANPERKINS;
ART DIRECTOR/DESIGNER, RON SULLIVAN;
ILLUSTRATOR/ARTIST, RON SULLIVAN

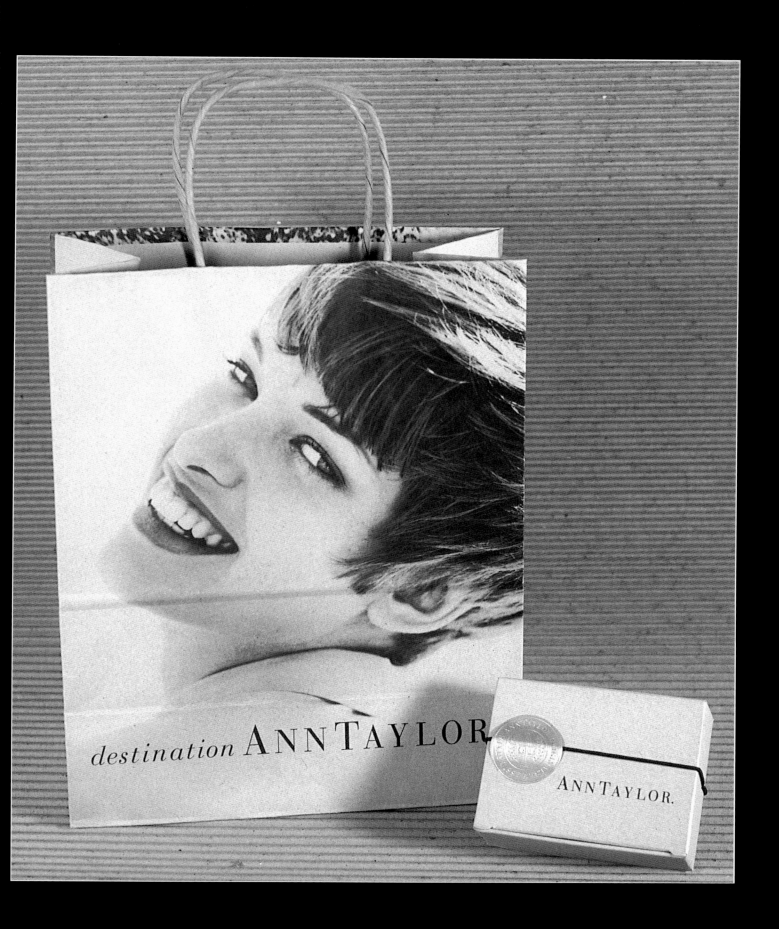

destination ANN TAYLOR

ANN TAYLOR.

ANN TAYLOR
DESIGN FIRM, CATO GOBE;
ART DIRECTOR, MARC GOBE;
DESIGNER, PETER LAVINE;

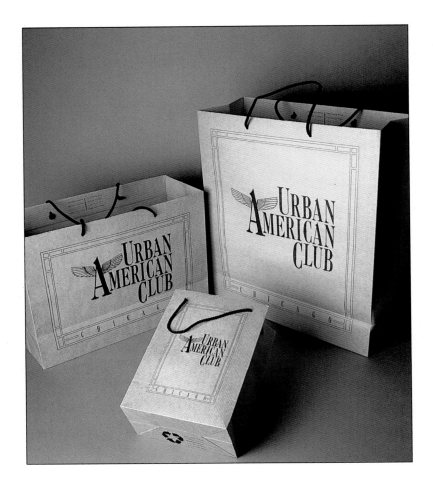

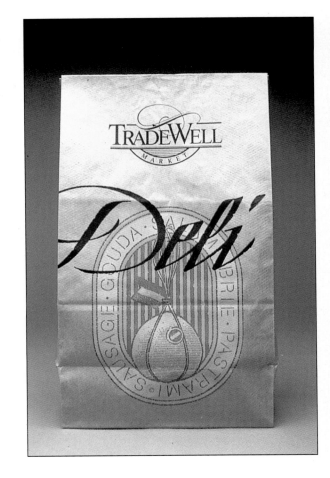

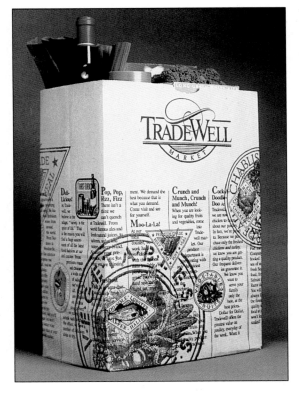

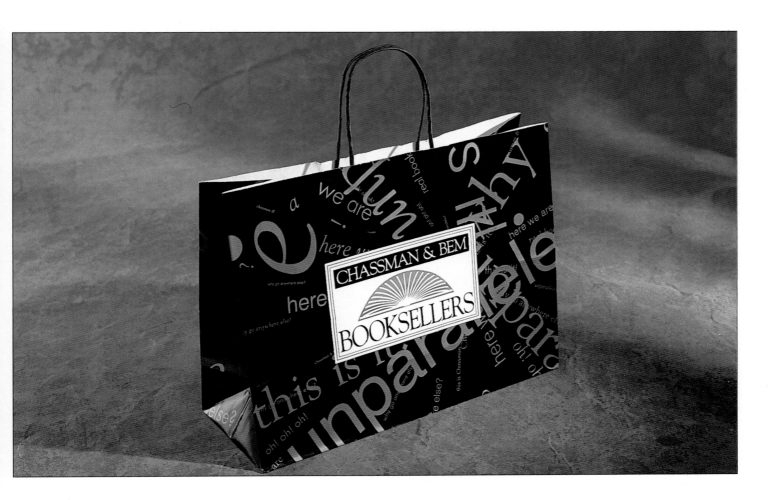

TOP
CHASSMEN & BEM BOOKSTORE
DESIGN FIRM, JAGER DI PAOLA KEMP DESIGN;
ART DIRECTOR, MICHAEL JAGER;
DESIGNERS, MICHAEL JAGER, GIOVANNA JAGER

BOTTOM
BOSTON GLOBE PROJECT
DESIGN FIRM, CLIFFORD SELBERT DESIGN;
ART DIRECTOR/DESIGNER, CLIFFORD SELBERT,
ROBIN PERKINS

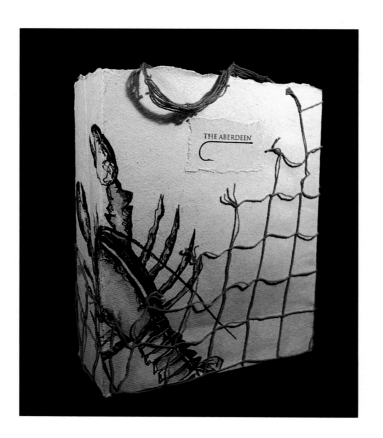

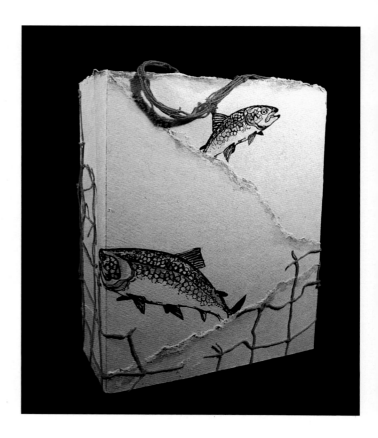

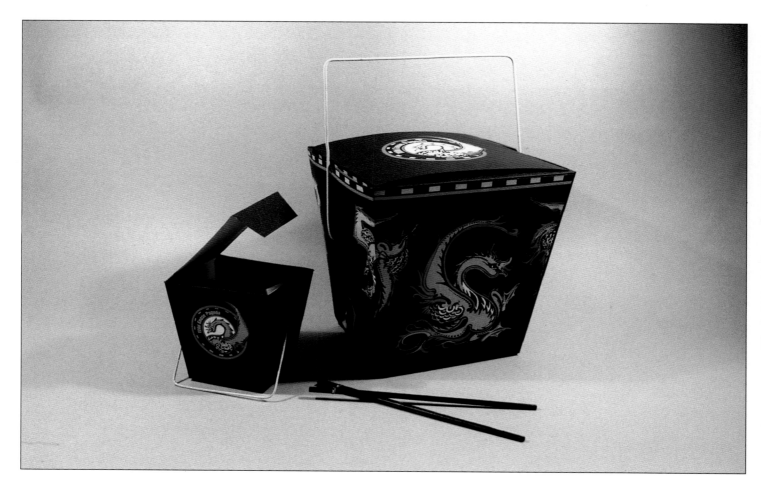

TOP

THE ABERDEEN (SEAFOOD SHOP)
DESIGN FIRM, ART 497.1-PENN STATE UNIVERSITY;
ART DIRECTOR, KRISTIN SOMMESE;
DESIGNER, GENNIFER BALL;

BOTTOM

WILD GOOSE PAGODA
DESIGN FIRM, ART 497.1 - PENN STATE UNIVERSITY;
ART DIRECTOR, KRISTIN SOMMESE;
DESIGNER, ROBINSON SMITH

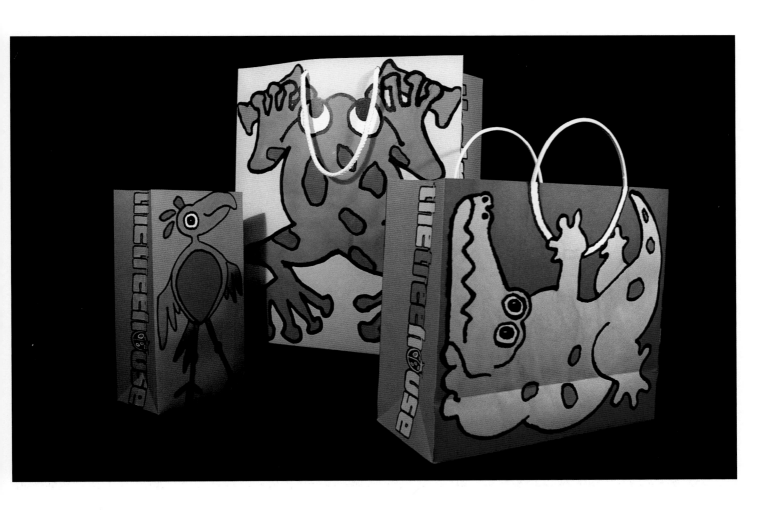

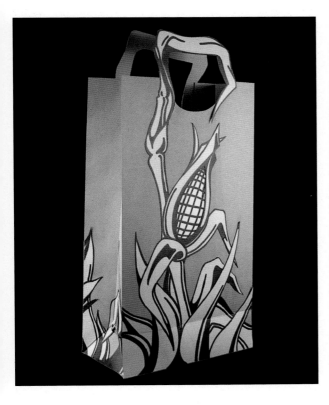

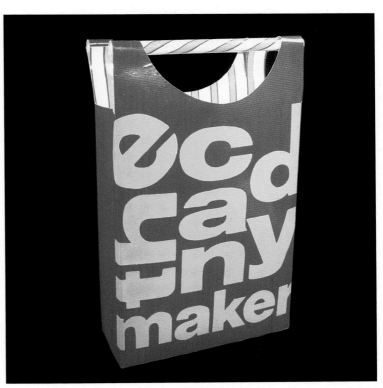

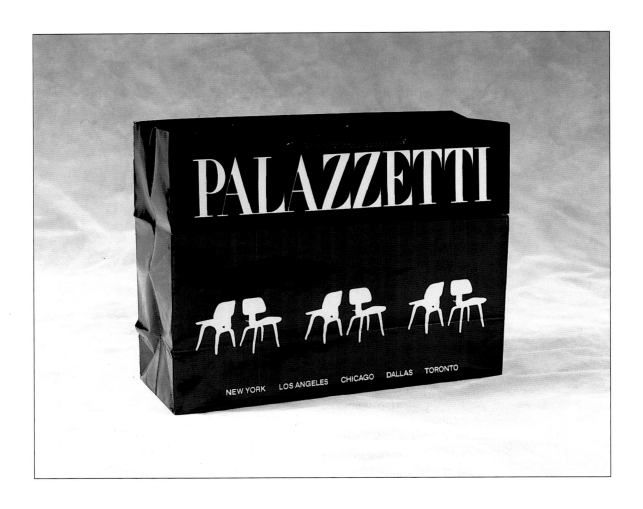

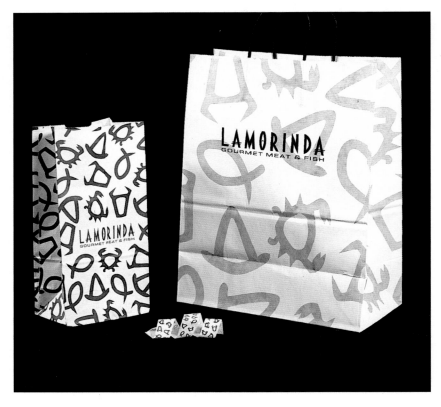

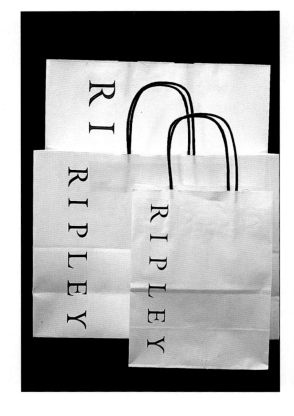

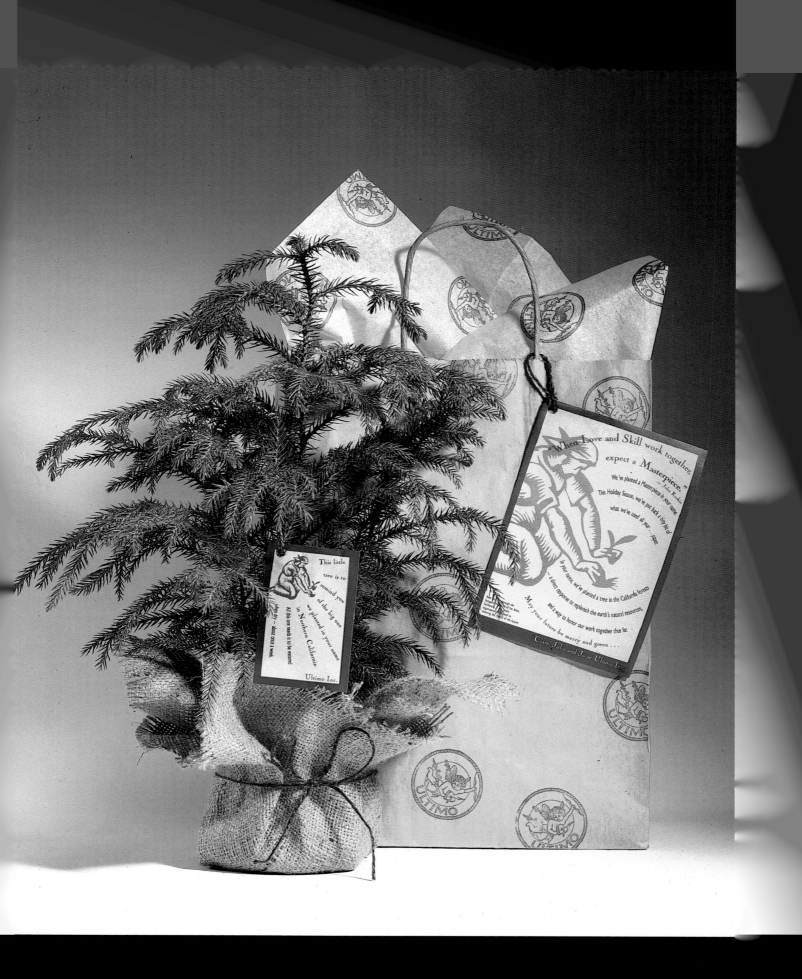

When Love and Skill work together,
expect a Masterpiece.
— John Ruskin

We've planted a Masterpiece by your name
This Holiday Season, we've put back a tiny bit of
what we've used all year '1990.

In your name, we've planted a tree in the California forests
— a direct response to replenish the earth's natural resources,
and a way to honor our work together thus far.

May your future be merry and green . . .

Clare, Julie and Jo at Ultimo Inc.

This little
tree is to
remind you
of the big one
we planted in your name
in Northern California.
All this one needs is to be watered
about once a week.

Ultimo Inc.

MO, INC.

GN FIRM, ULTIMO, INC.;

DIRECTOR, CLARE ULTIMO;

SNER, CLARE ULTIMO, JULIE HUBER

IN GIVING HOLIDAY GIFTS TO OUR CLIENTS FOR THE 1990
SEASON, WE DECIDED TO "GIVE BACK" TO OUR ENVIRON-
MENT AS WELL. SINCE GRAPHIC DESIGNER BECOME PART
OF THE PROBLEM WHEN IT COMES TO WASTING OUR

BY A PRESERVATION GROUP IN CALIFORNIA, IN HONOR
OF EACH OF OUR CLIENTS. THEN WE GAVE EACH CLIENT
A SMALL TREE TO MARK THE EVENT. THE PAPER USED
FOR THE GIFT CARDS WAS RECYCLABLE, AND THE INKS

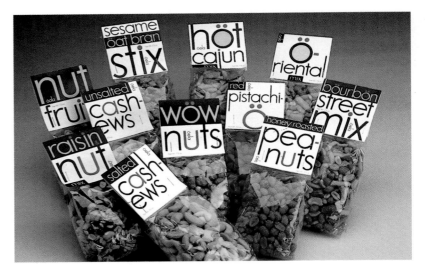

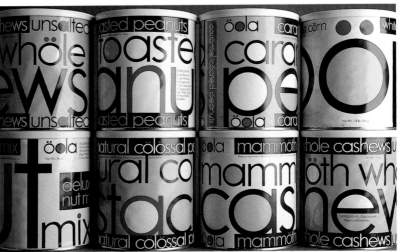

Packaging design for Öola Corporation, a chain of Swedish candy stores in American shopping malls. **Design Firm, Pentagram, New York, New York; Partner and Designer, Paula Scher.**

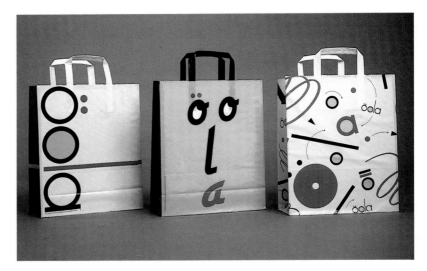

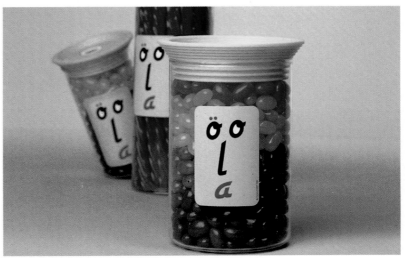

CAO FANTASIE CHOCOLATS
E ICE CUPS WITH A UNIQUE
NT-COCOA FLAVORING.
SIGN FIRM,
LFORD-VAN DEN BERG
SIGN, B.V., HOLLAND;
EATIVE DIRECTOR AND
SIGNER, DANNY KLEIN;
USTRATOR,
NS REISINGER.

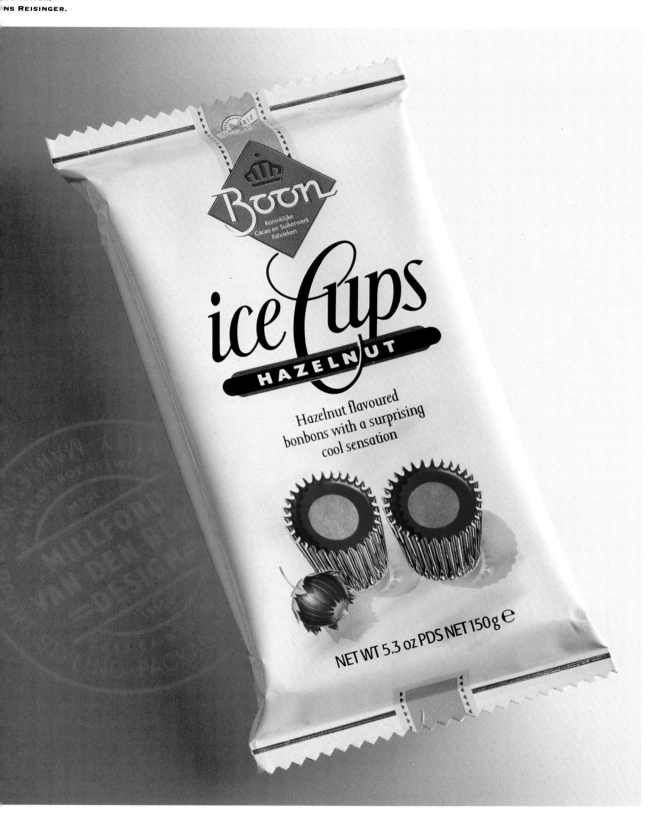

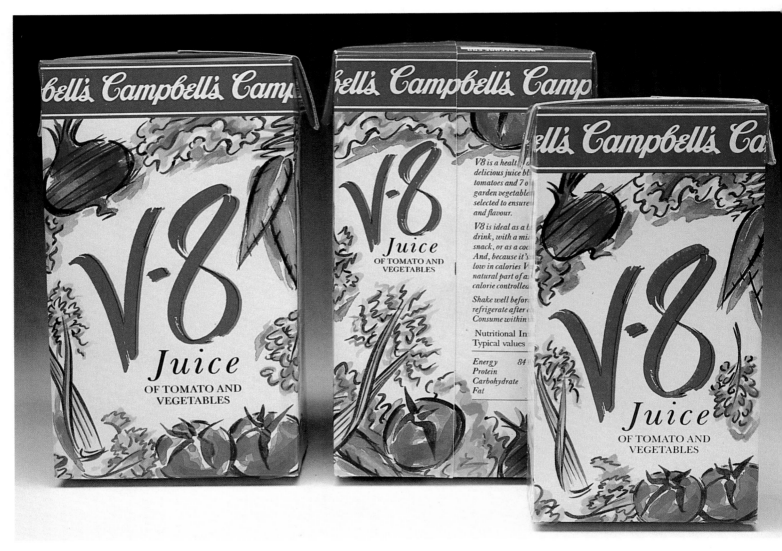

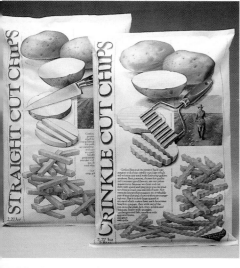

Argyll Foods' Cordon Bleu is a range of frozen cut potato chips.
**Design Firm,
Michael Peters Limited,
London; Art Director and
Designer, Glenn Tutssel;
Illustrator,
Bob Haberfield.**

Cordon Bleu Vegetables show natural ingredients right on the packs.
**Design Firm,
Michael Peters Limited,
London; Art Director and
Designer, Glenn Tutssel;
Illustrator,
Bob Haberfield.**

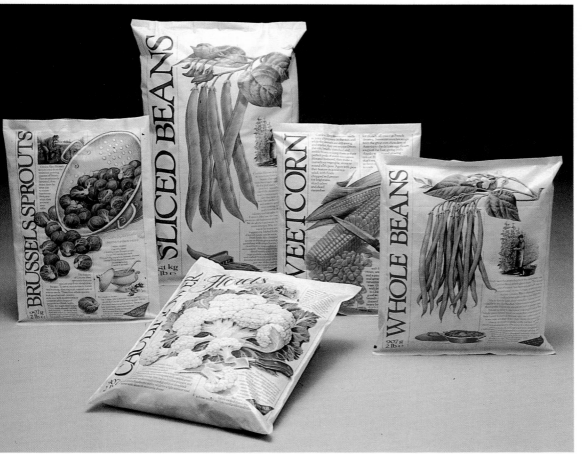

FABULOUS FLATS IS A SERIES
OF STAND UP PIECES THAT WAS
EXPANDED AFTER THE EXTREM-
ELY SUCCESSFUL LAUNCH OF
FLAT CAT. EACH PIECE IS A
LIFE-SIZE CARDBOARD DIE-CUT
WITH EASEL.
**DESIGNED BY BLUE Q,
BOSTON, MASSACHUSETTS;
DESIGNERS, MITCH NASH,
SETH NASH.**

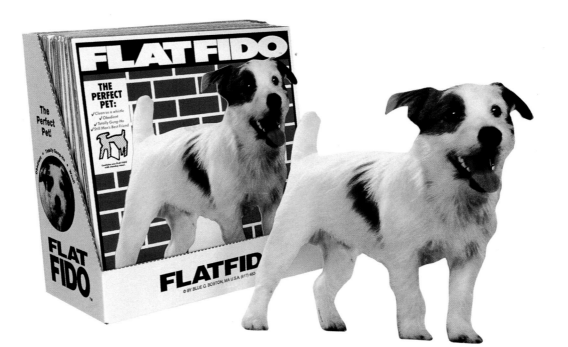

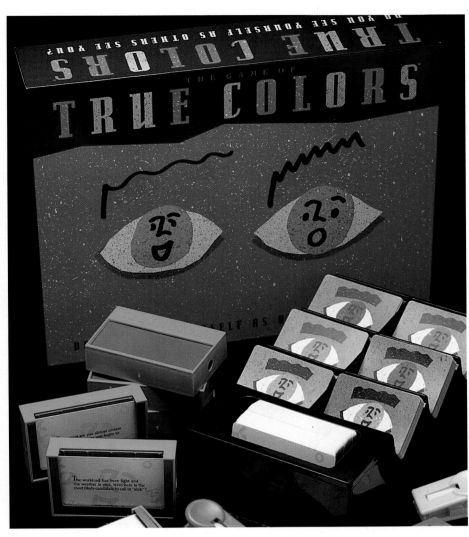

MILTON BRADLEY'S TRUE
COLORS IS AN ADULT GAME
WHERE PLAYERS ARE ASKED
QUESTIONS AND THEN SCORE
POINTS BY CORRECTLY
GUESSING HOW MANY PLAYERS
VOTED FOR YOUR ANSWERS.
**DESIGN FIRM,
SIBLEY/PETEET DESIGNS,
DALLAS, TEXAS;
ART DIRECTORS, DON SIBLEY,
JIM BREMER;
DESIGNER AND ILLUSTRATOR,
DIANA McKNIGHT.**

TABOO IS A MILTON BRADLEY
GAME TARGETED TO THE ADULT
MARKET, AND REQUIRES
PLAYERS TO GUESS SECRET
WORDS BY AVOIDING CERTAIN
TABOO CLUE WORDS.
**DESIGN FIRM,
SIBLEY/PETEET DESIGN,
DALLAS, TEXAS; DESIGNER
AND ILLUSTRATOR,
DON SIBLEY; ART DIRECTORS,
DON SIBLEY, JIM BREMER.**

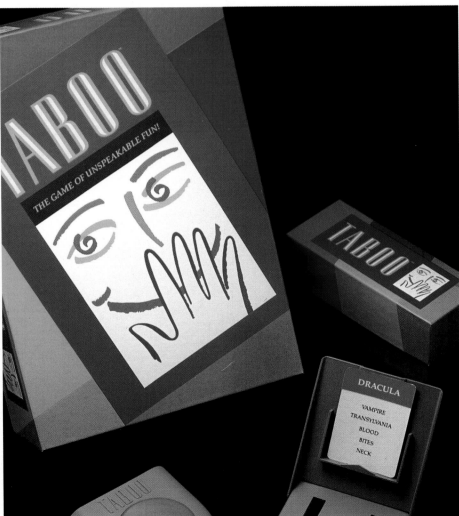

PACKAGE DESIGN FOR SE
OF W.H. SMITH GA
DESIGN
MICHAEL PETERS LIM
LONDON; ART DIREC
GLENN TUTSSEL; DESIG
CAROLINE WA
ILLUSTRATION, W.I.

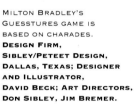

MILTON BRADLEY'S
GUESSTURES GAME IS
BASED ON CHARADES.
**DESIGN FIRM,
SIBLEY/PETEET DESIGN,
DALLAS, TEXAS; DESIGNER
AND ILLUSTRATOR,
DAVID BECK; ART DIRECTORS,
DON SIBLEY, JIM BREMER.**

PACKAGE DESIGNS FOR MILTON
BRADLEY'S SCATTERGORIES JR.
GAME.
**DESIGN FIRM,
SIBLEY/PETEET DESIGN,
DALLAS, TEXAS; DESIGNER
AND ILLUSTRATOR,
JOHN EVANS; ART DIRECTORS,
DON SIBLEY, JIM BREMER.**

WHSMITH

GOLD COLOUR MARKER

Extra fine point
Caution: contains toxic substances

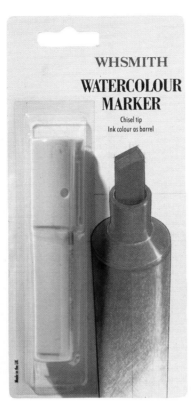

WHSMITH

WATERCOLOUR MARKER

Chisel tip
Ink colour as barrel

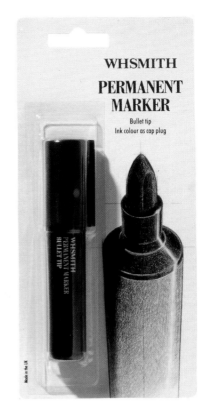

WHSMITH

PERMANENT MARKER

Bullet tip
Ink colour as cap plug

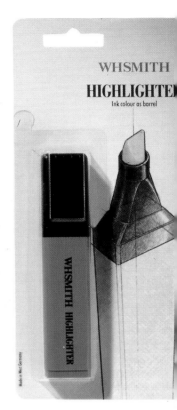

WHSMITH

HIGHLIGHTER

Ink colour as barrel

PACKAGING FOR W.H. SMITH BRAND WRITING INSTRUMENTS. DESIGN FIRM, NEWELL AND SORRELL, LTD., LONDON; CREATIVE DIRECTOR, JOHN SORRELL; ART DIRECTOR, JEREMY SCHOLFIELD; DESIGNER, GILLIAN THOMAS; ILLUSTRATORS, JONATHAN WRIGHT, RICHARD OSLEY.

BEROL "KARISMA" DOUBLE-ENDED MARKERS. DESIGN FIRM, NEWELL AND SORRELL, LTD., LONDON; CREATIVE DIRECTORS, JOHN SORRELL, FRANCES NEWELL; DESIGNER, DERICK HUDSPITH.

OPPOSITE PAGE: BEROL "KARISMA" COLOUR PENCILS HAVE CHAMFERED ENDS. THE OUTER PACKAGING IS RECYCLED PAPER EMBOSSED WITH HALLMARKS. DESIGN FIRM, NEWELL AND SORRELL, LTD., LONDON; CREATIVE DIRECTORS, JOHN SORRELL, FRANCES NEWELL; DESIGNER, DERICK HUDSPITH; PHOTOGRAPHER, PETER MANSFIELD.

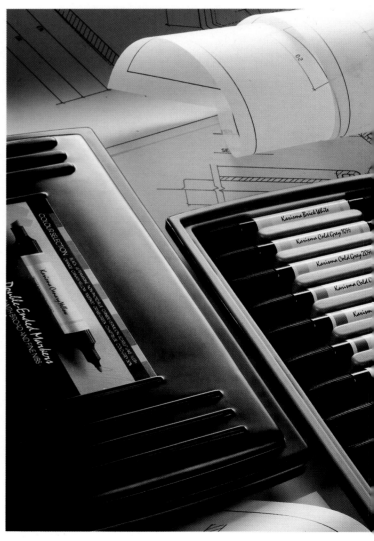

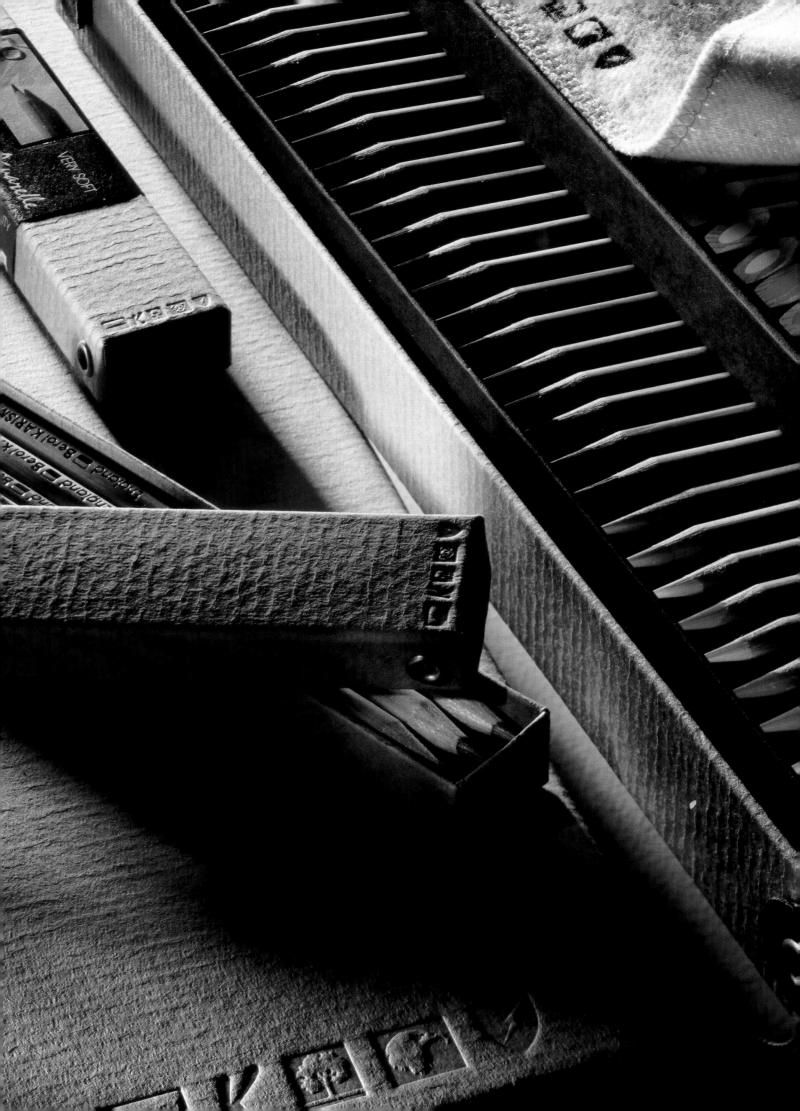

LABEL DESIGN FOR MESSINIA
SUPERIOR-QUALITY EXTRA-
VIRGIN OLIVE OIL.
**DESIGN FIRM,
LOUISE FILI LTD.,
NEW YORK, NEW YORK;
ART DIRECTOR AND DESIGNER,
LOUISE FILI; ILLUSTRATOR,
MELANIE PARKS.**

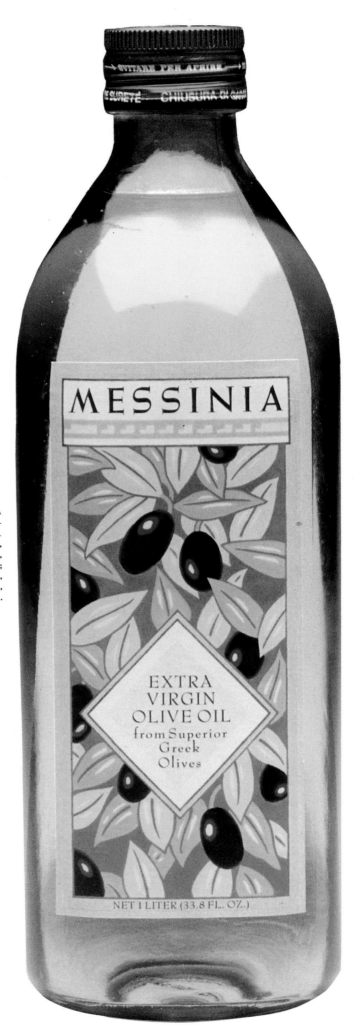

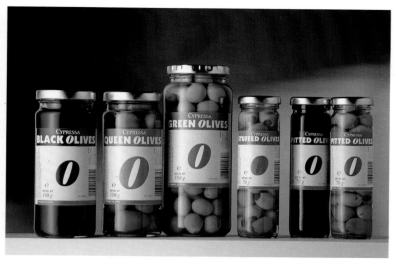

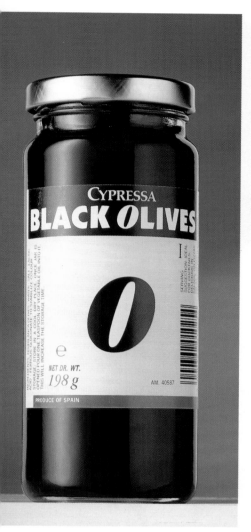

CYPRESSA OLIVES PACKAGING
DISPLAYS THE PRODUCTS IN
ALL THEIR GLORY. A SIMPLE
TYPOGRAPHIC DEVICE IS USED
TO DIFFERENTIATE VARIETIES.
DESIGN FIRM,
CARTER WONG LIMITED,
LONDON; ART DIRECTOR AND
DESIGNER, PHILIP CARTER.

NAME DEVELOPMENT, BRAND
IDENTITY AND PACKAGE DESIGN
OF SAVOIR FAIRE, A GOURMET
LINE OF CONDIMENTS AND
CRACKERS FROM FRANCE.
DESIGN FIRM,
LANDOR ASSOCIATES,
SAN FRANCISCO, CALIFORNIA;
DESIGNERS, LANDOR
NEW YORK DESIGN STAFF.

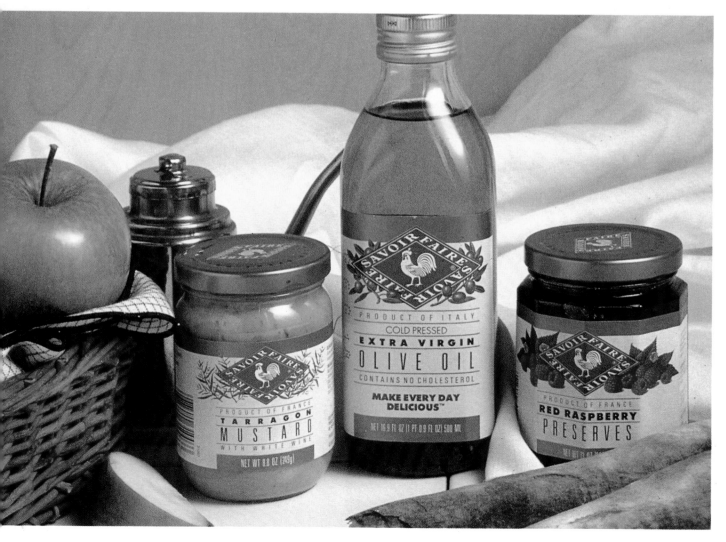

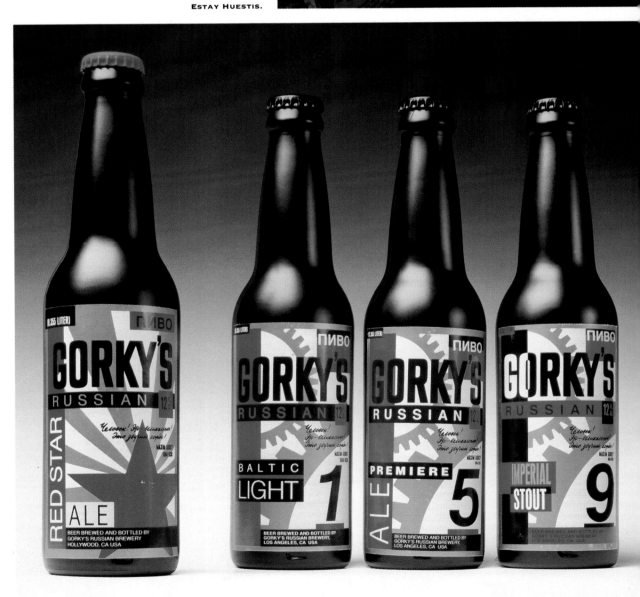

OPPOSITE P/
PACKAGING DESIGN FOR
HOT BAGEL COMPANY, LON
DESIGN F
NEWELL AND SORRELL, L
LON
CREATIVE DIRECT
JOHN SORR
DESIGNER, DOMENIC LI

PACKAGE DESIGN FOR
JUST DESSERTS.
DESIGN FIRM, PRIMO ANGELI,
INC., SAN FRANCISCO,
CALIFORNIA; DESIGNER,
PRIMO ANGELI.

BEER BOTTLES AND LABEL
DESIGNS FOR GORKY'S CAFE
AND BREWERY, LOS ANGELES.
DESIGN FIRM,
30/SIXTY ADVERTISING AND
DESIGN, LOS ANGELES,
CALIFORNIA; DESIGNERS,
HENRY VIZCARRA,
ESTAY HUESTIS.

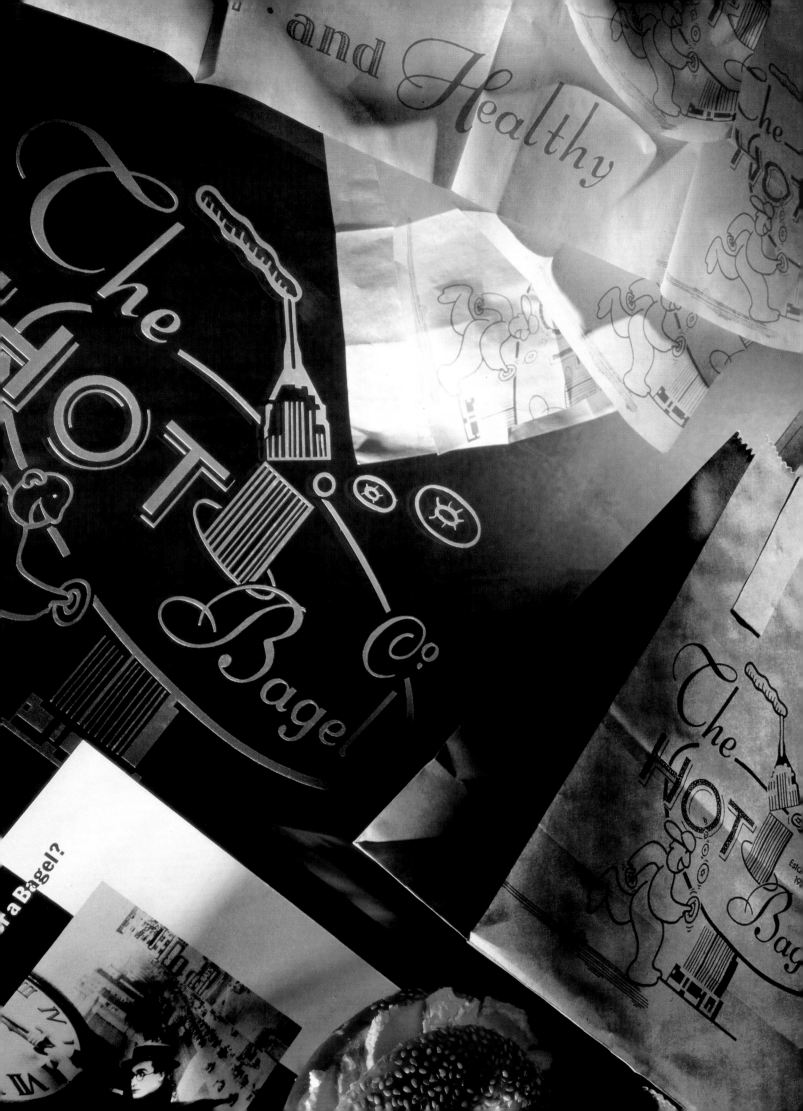

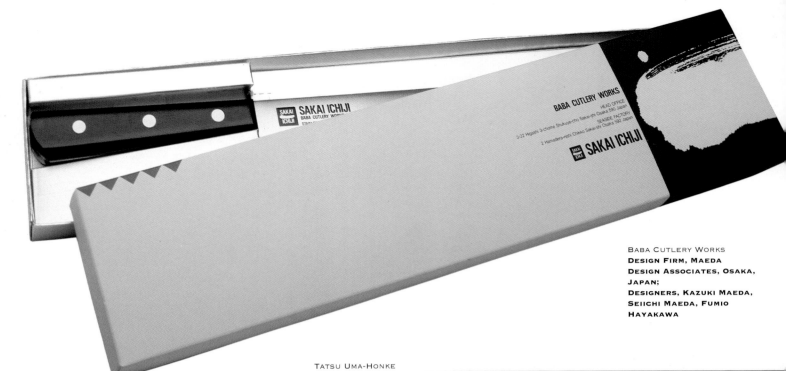

BABA CUTLERY WORKS
DESIGN FIRM, MAEDA
DESIGN ASSOCIATES, OSAKA,
JAPAN;
DESIGNERS, KAZUKI MAEDA,
SEIICHI MAEDA, FUMIO
HAYAKAWA

TATSU UMA-HONKE
BREWING CO., INC.
DESIGN FIRM, MAEDA
DESIGN ASSOCIATES,
OSAKA, JAPAN;
DESIGNERS, KAZUKI MAEDA,
YARAKASUKAN, SHUJI
UEDA, SEIICHI MAEDA

FENWICK
DESIGN FIRM, HARTE
YAMASHITA & FOREST,
LOS ANGELES, CA;
DESIGNER, SUSAN HEALY

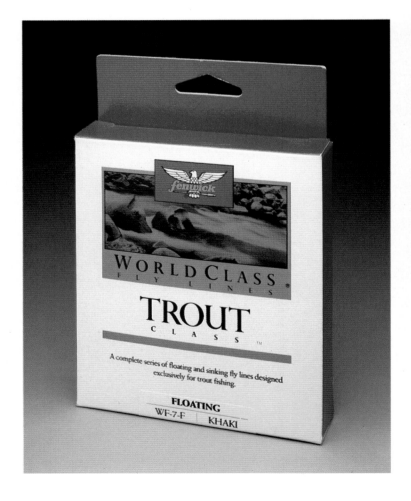

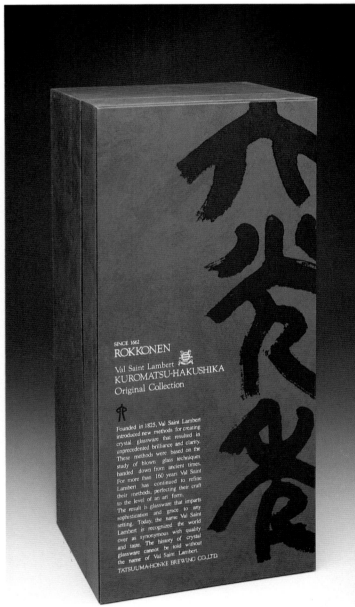

**DESIGN FIRM, DESIGN NORTH,
RACINE, WI**

**DESIGN FIRM, SELAME DESIGN,
NEWTON, MA**

A RANGE OF BUTTERS AND
CREAMS FOR CANDIA, SOLD
TO PROFESSIONAL
BAKERS IN FRANCE
**DESIGN FIRM, B.E.P. DESIGN
GROUP, BRUSSELS, BELGIUM;
DESIGNERS, BRIGITTE EVRARD,
CAROLE PURNELLE.**

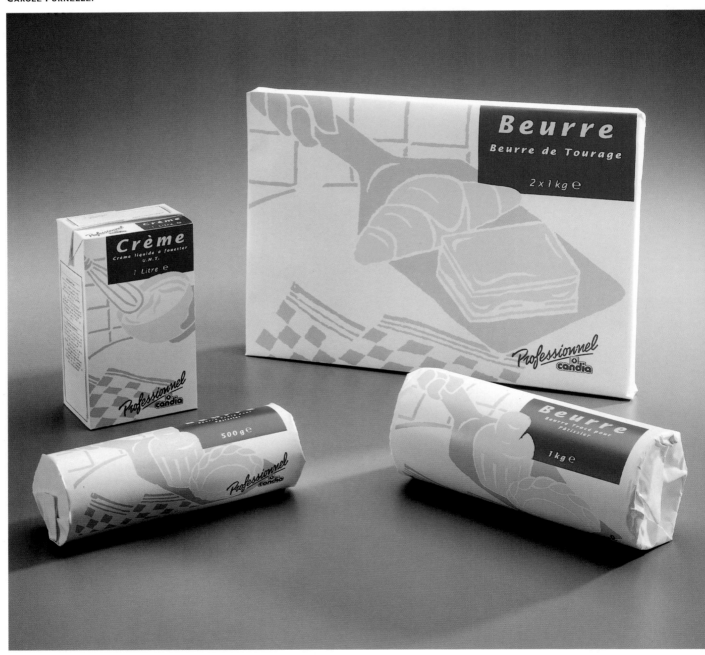

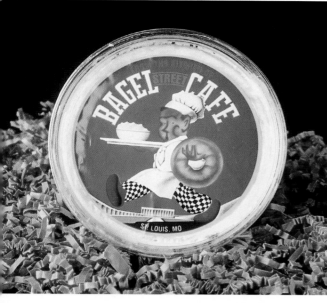

Bagel Street Café cream cheese
Design Firm,
Muller and Company,
Kansas City, Missouri;
Designer, Michelle Krauss.

C & H Magic Sugar
Design Firm,
Addison Design
Consultants Worldwide,
San Francisco, California;
Designers, Eileen Limsico and
Micaela Mercé.

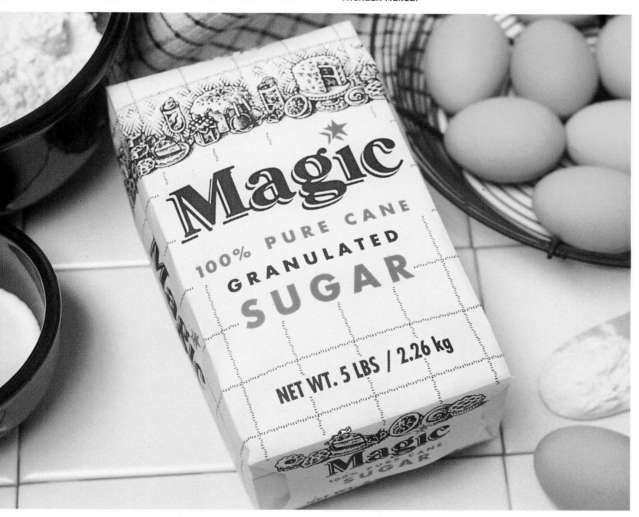

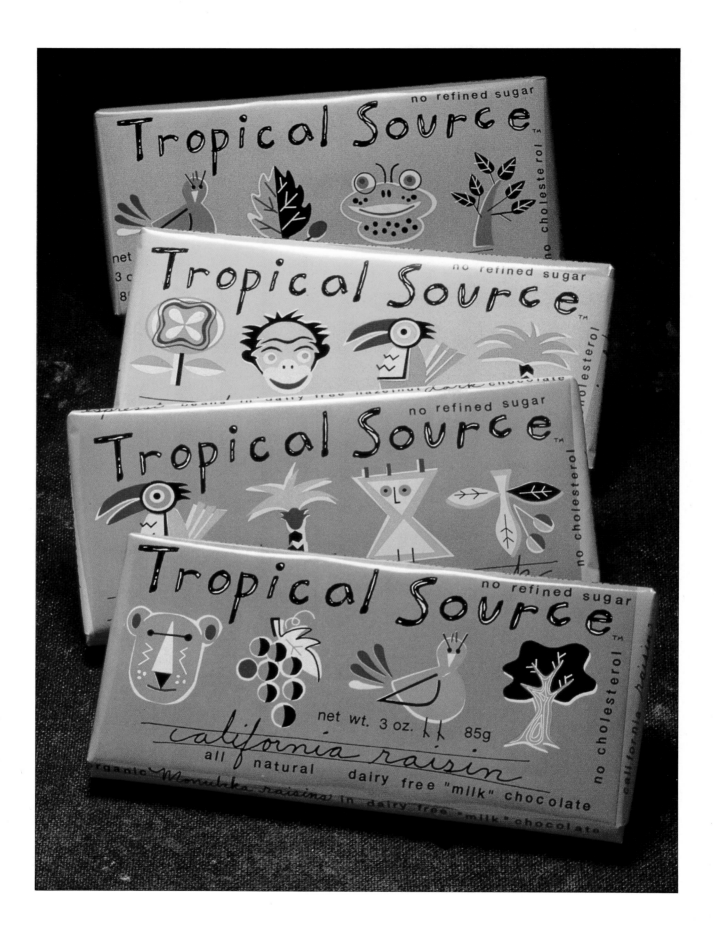

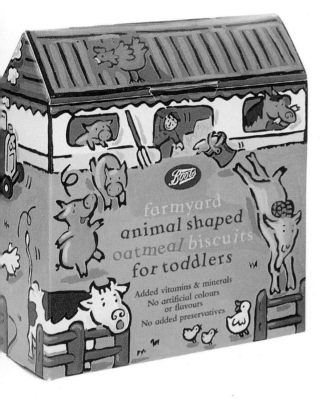

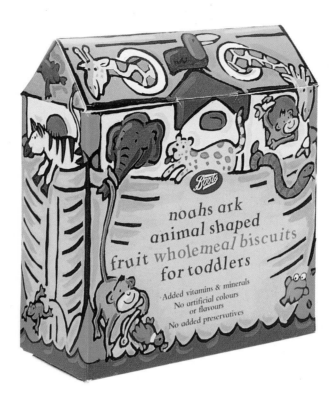

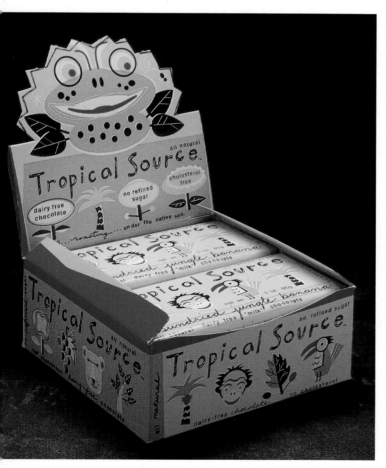

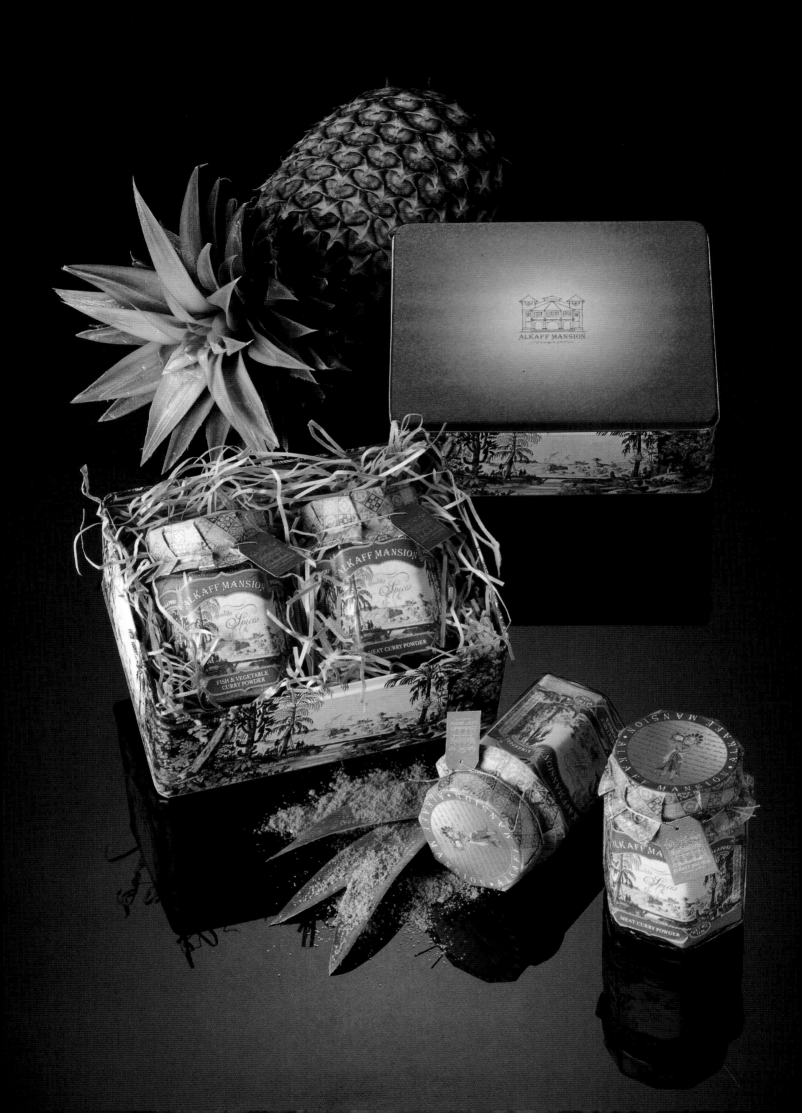

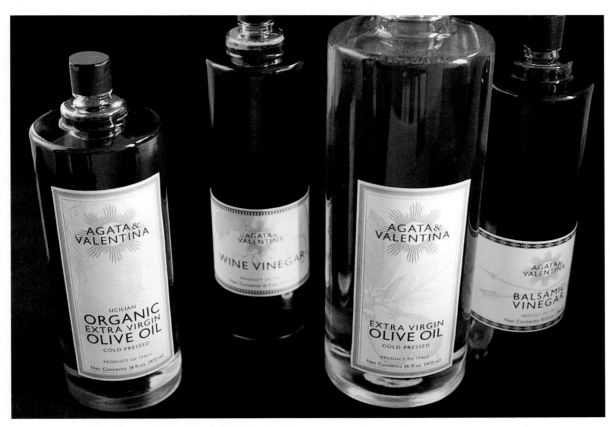

AGATA AND VALENTINA
DESIGN FIRM,
DRENTTEL DOYLE
PARTNERS,
NEW YORK, NEW YORK;
CREATIVE DIRECTOR,
STEPHEN DOYLE;
DESIGNER,
GARY TOTH.

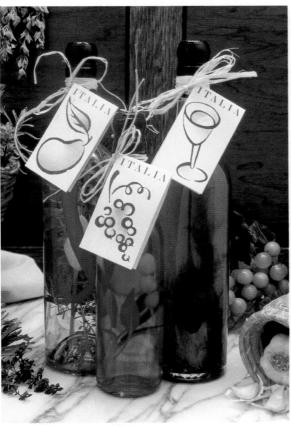

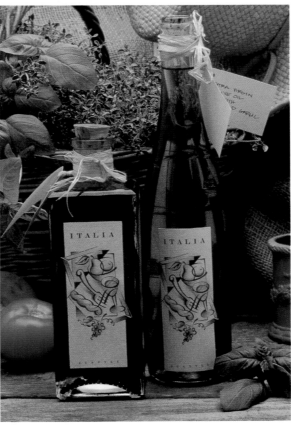

AGATA VALENTINE OLIVE OIL
DESIGN FIRM,
DRENTTEL DOYLE PARTNERS,
NEW YORK, NEW YORK.

WINE BOTTLES FOR ITALIA
DESIGN FIRM,
HORNALL ANDERSON DESIGN
WORKS, INC.,
SEATTLE, WASHINGTON;
DESIGNERS,
JACK ANDERSON AND
JULIA LA PINE.

GROOVE DOTS chocolates
DESIGN FIRM, ROSENWORLD,
NEW YORK, NEW YORK;
DESIGNER,
LAURIE ROSENWALD.

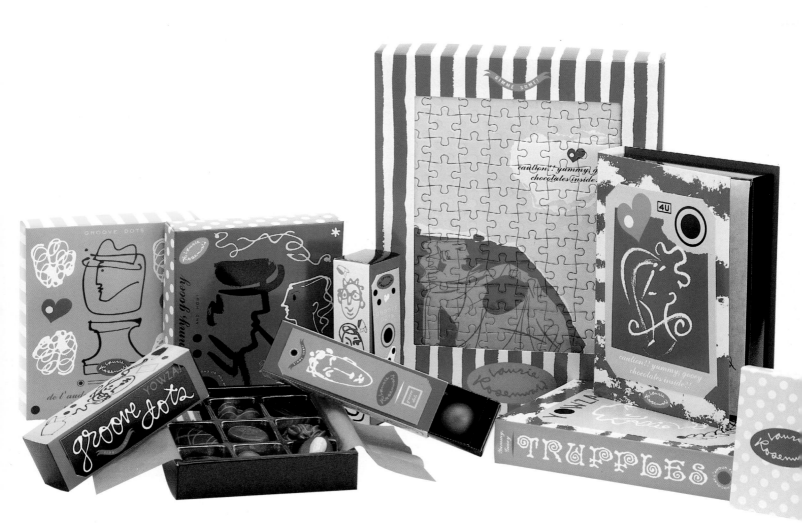

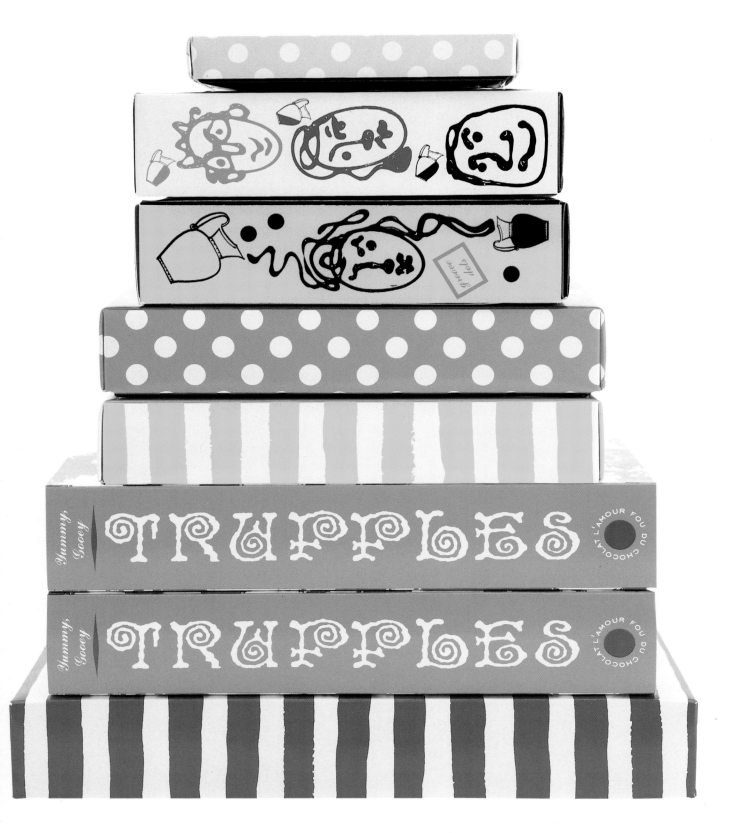

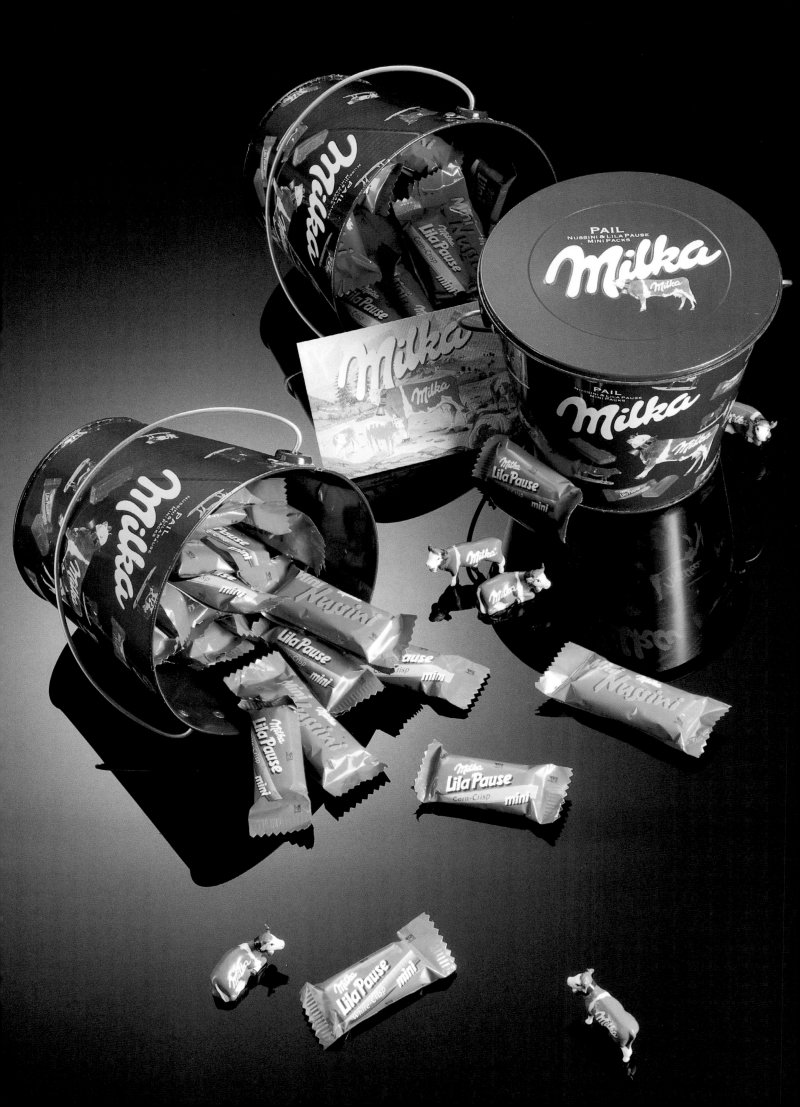

MILKA, A CHOCOLATE
MANUFACTURED BY KRAFT
GENERAL FOODS INTERNATIONAL
DESIGN FIRM,
ALAN CHAN DESIGN COMPANY,
WANCHAI, HONG KONG;
CREATIVE DIRECTORS,
ALAN CHAN AND PETER LO.

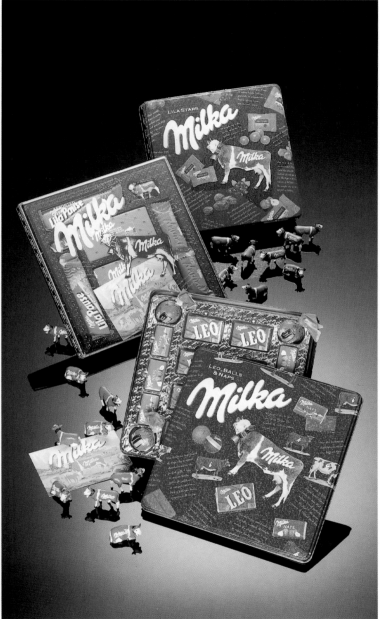

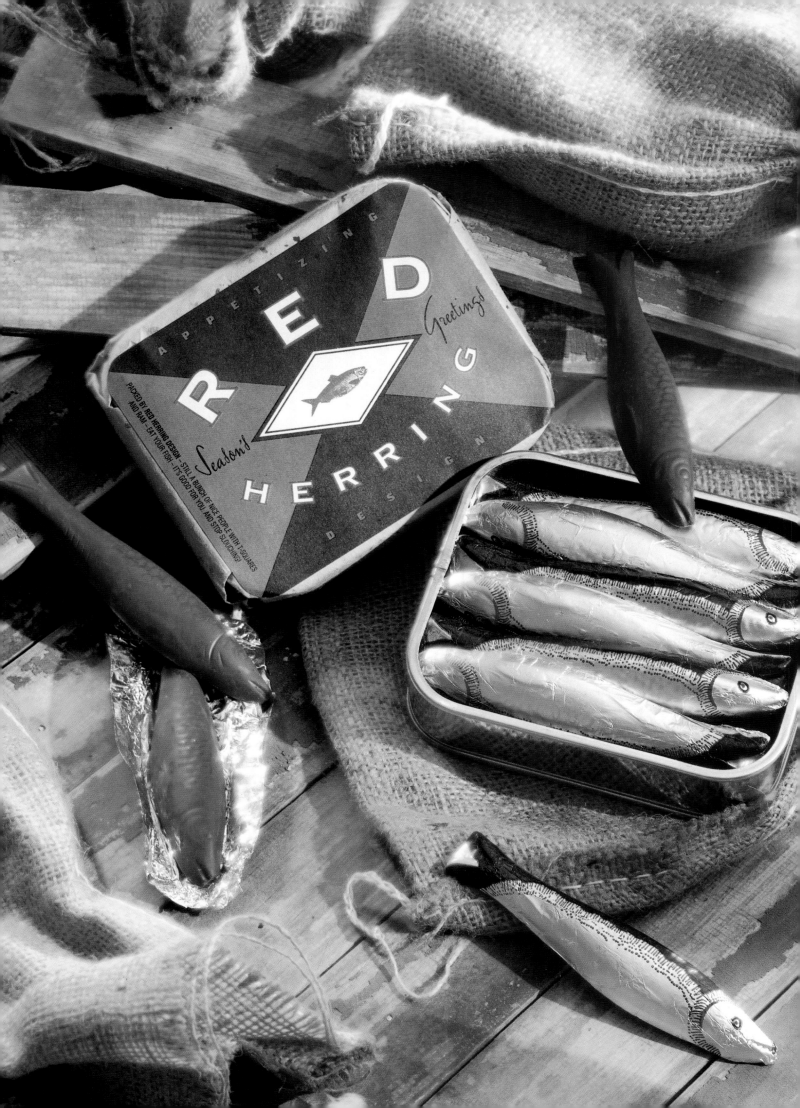

RED
HERRING

APPETIZING

Season's

Greetings

DESIGN

PACKED BY RED HERRING DESIGN - STILL A BUNCH OF NICE PEOPLE WITH T-SQUARES
AND RAM - EAT YOUR FISH - IT'S GOOD FOR YOU AND STOP SLOUCHING!

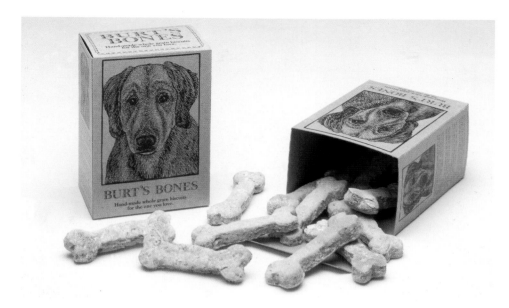

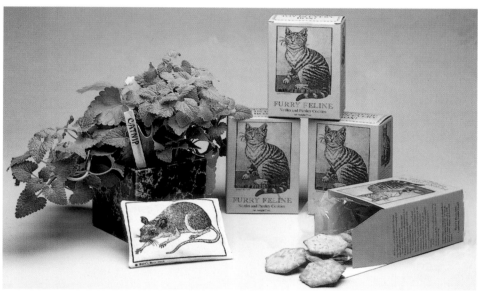

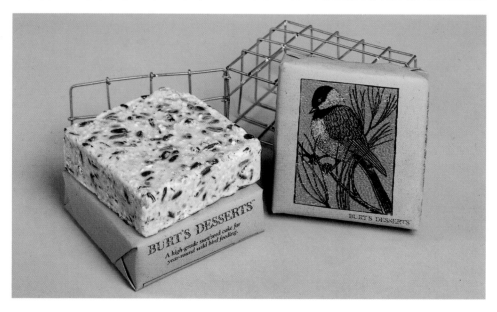

BURT'S BONES, DOG BISCUITS,
FURRY FELINE CAT BISCUITS,
AND BURT'S DESSERTS,
BIRD FOOD
DESIGNED BY, BURT'S BEES,
CREEDMOOR, NORTH CAROLINA.

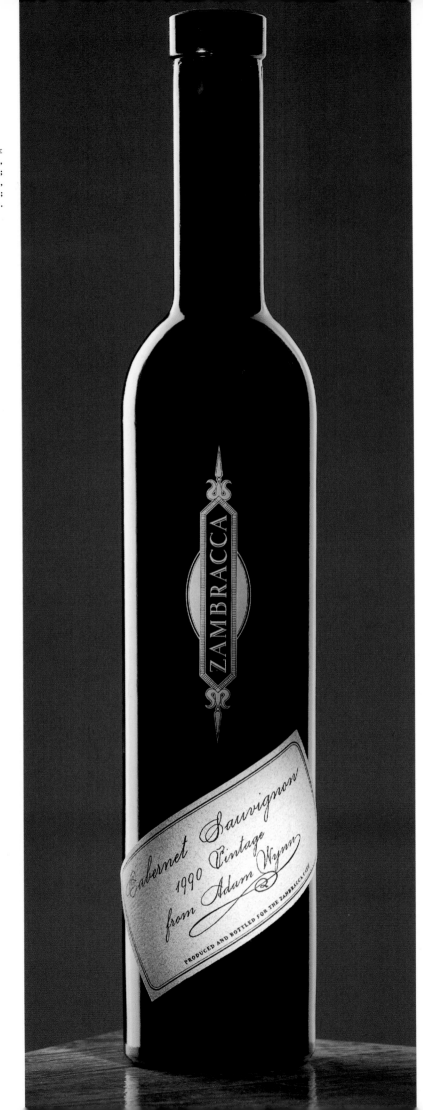

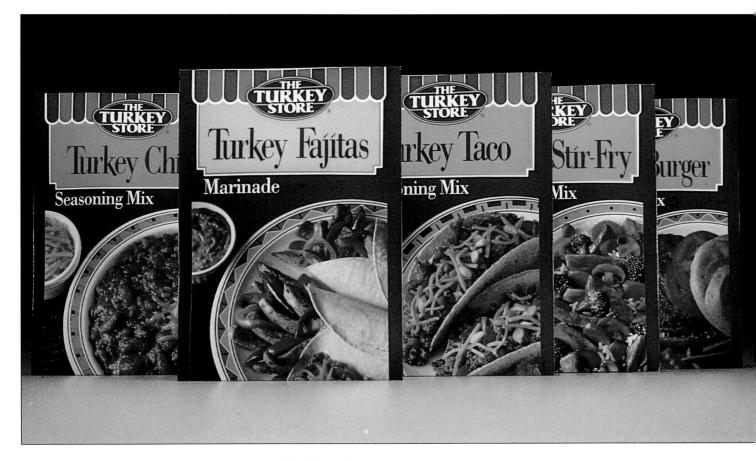

THE TURKEY STORE
DESIGN FIRM, HILLIS MACKEY & CO., INC.,
MINNEAPOLIS, MN

TOWNHOUSE
DESIGN FIRM,
PROFILE DESIGN,
SAN FRANCISCO, CA

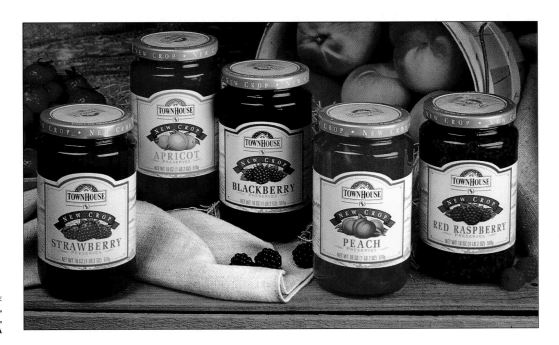

ICONOPOLIS
SUPON DESIGN GROUP, INC.
WASHINGTON, DC;
DESIGNERS, SUPON
PHORNIRUNLIT, RICHARD
LEE HEFFNER

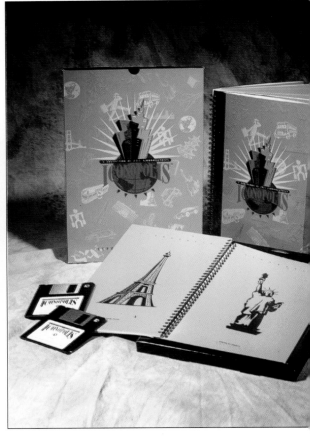

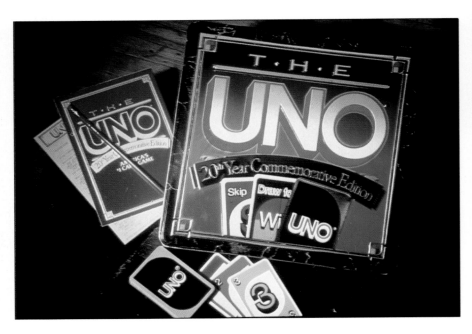

INTERNATIONAL GAMES,
INC.
DESIGN FIRM, LIPSON-
ALPORT-GLASS &
ASSOCIATES,
NORTHBROOK, IL;
DESIGNERS, SAM J.
CIULLA, ANN WERNER,
GARY D. MAJUS

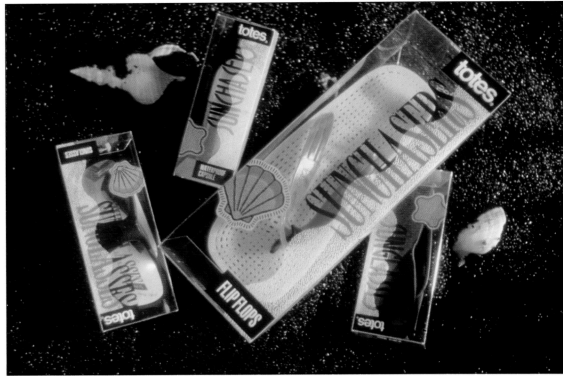

TOTES
DESIGN FIRM, LIBBY
PERSZYK KATHMAN,
CINCINNATI, OH;
DESIGNER, BRADDLY J.
BUSH, TINA FRITSCHE

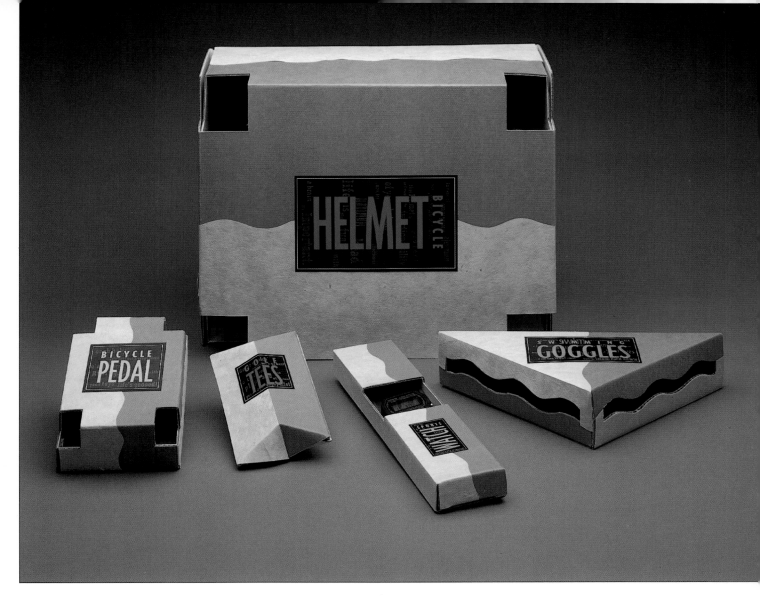

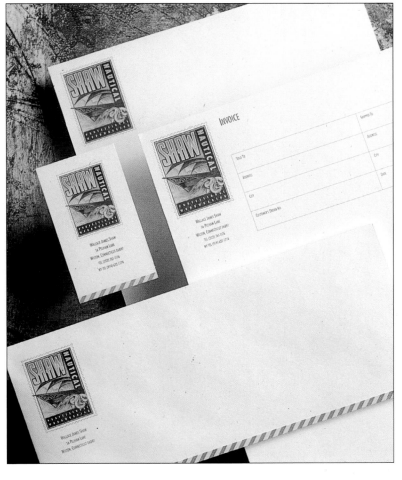

SECOND HAND ATHLETE
DESIGN FIRM, HENRIK
OLSEN, PASADENA, CA;
DESIGNER, HENRICK
OLSEN

SHAW NAUTICAL
DESIGN FIRM, WALLACE
CHURCH ASSOCIATES,
INC., NEW YORK, NY;
DESIGNERS, STANLEY
CHURCH, JOE CUTICONE

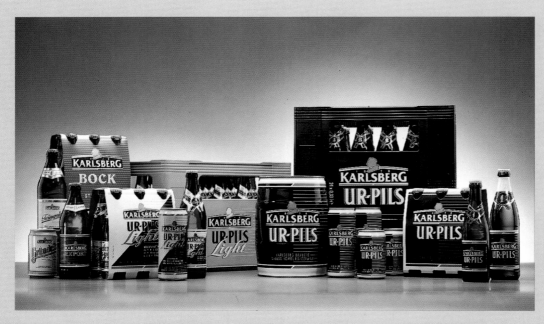

KARLSBERG BRAUEREI
DESIGN FIRM, B.E.P.
DESIGN GROUP,
BRUSSELS, BELGIUM;
DESIGNERS, GEORGE
ROSENFELD,
BRIGITTE EVRARD,
CAROLE PURNELLE

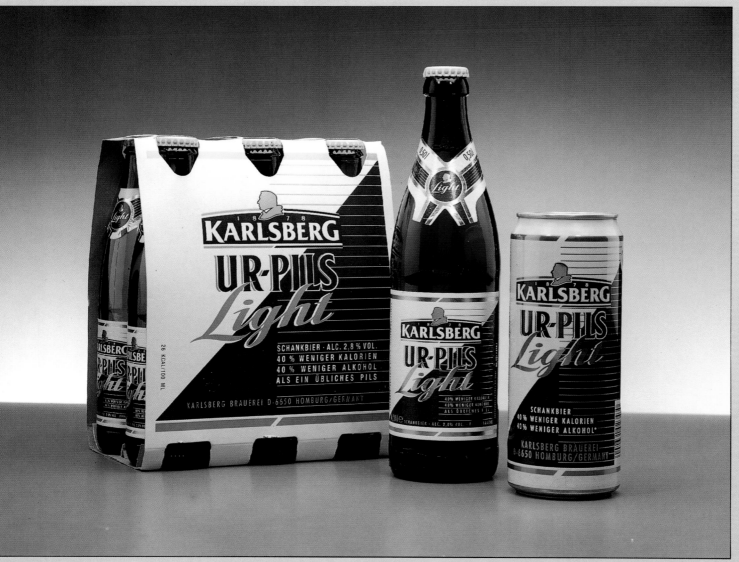

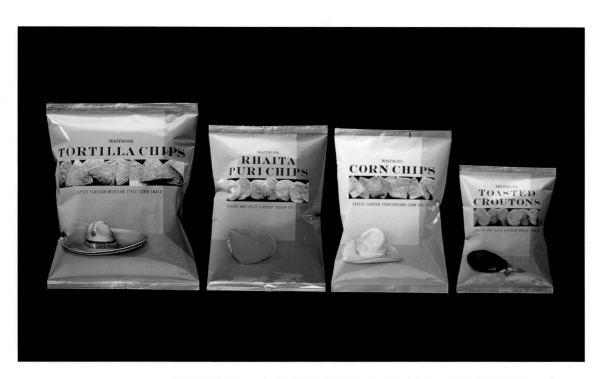

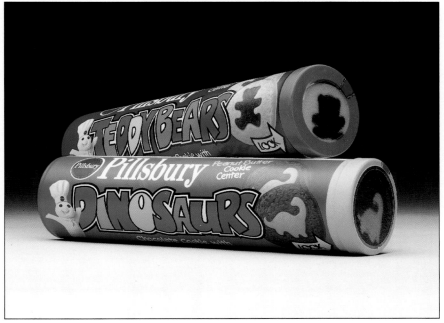

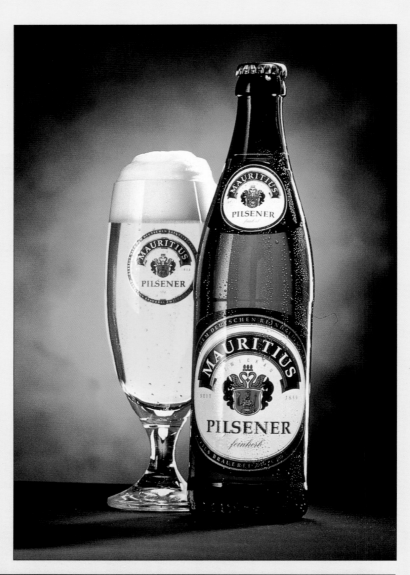

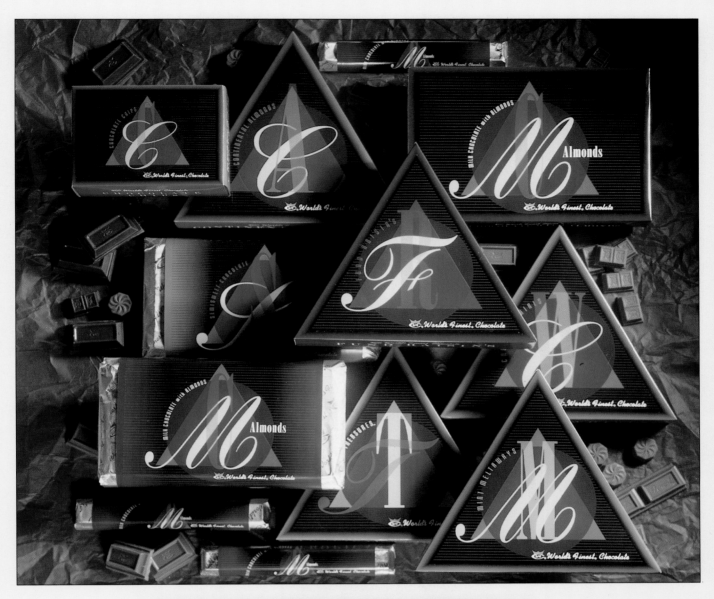

**DESIGN FIRM, DIDONATO
ASSOCIATES, CHICAGO, IL**

**DESIGN FIRM, ILIUM ASSOCIATES, INC.,
BELLEVUE, WA**

ANASAZI
DESIGN FIRM, MICHAEL STANARD, INC., EVANSTON, IL

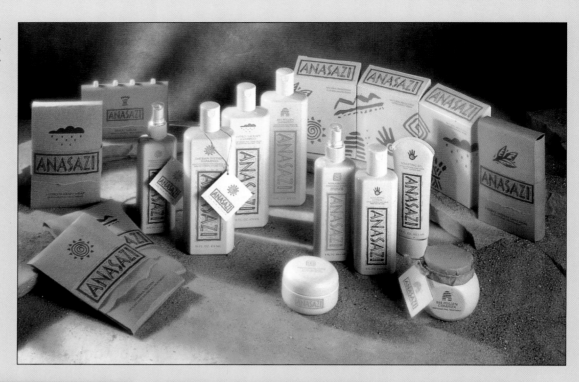

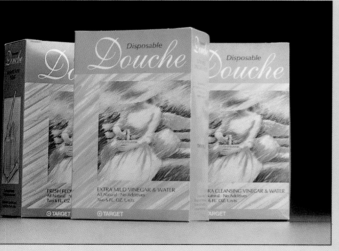

TARGET DOUCHE
DESIGN FIRM, HILLIS MACKEY & CO., INC., MINNEAPOLIS, MN

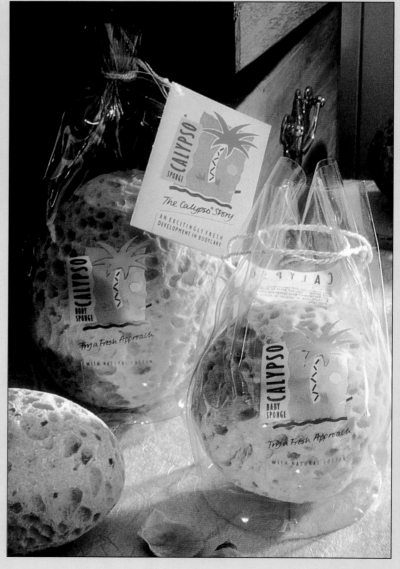

CALYPSO
DESIGN FIRM, FISHER LING & BENNION, CHELTENHAM, UK

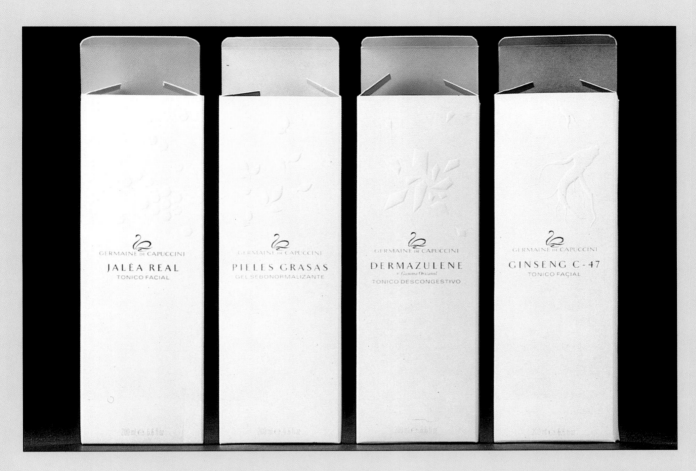

GERMAINE DE CAPPUCINI
**DESIGN FIRM, MILLER-SUTHERLAND,
LONDON, UK**

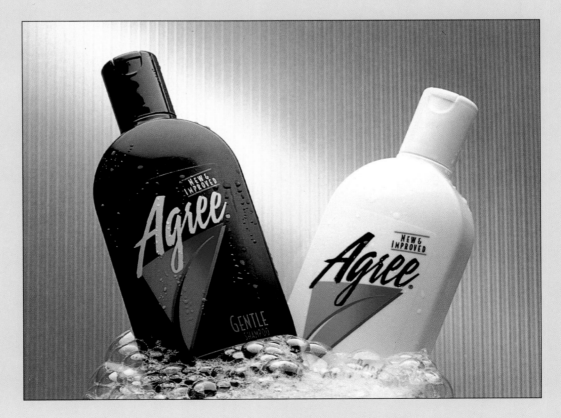

AGREE
**DESIGN FIRM,
LIPSON•ALPORT• GLASS &
ASSOCIATES,
NORTHBROOK, IL**

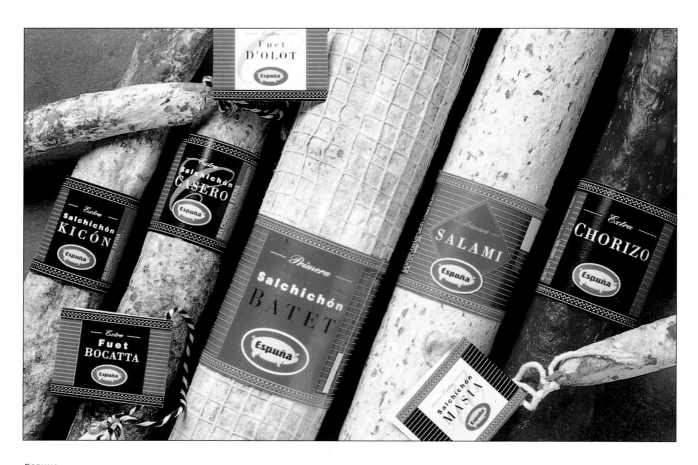

ESPUNA
MORILLAS & ASOCIADOS
BARCELONA, SPAIN

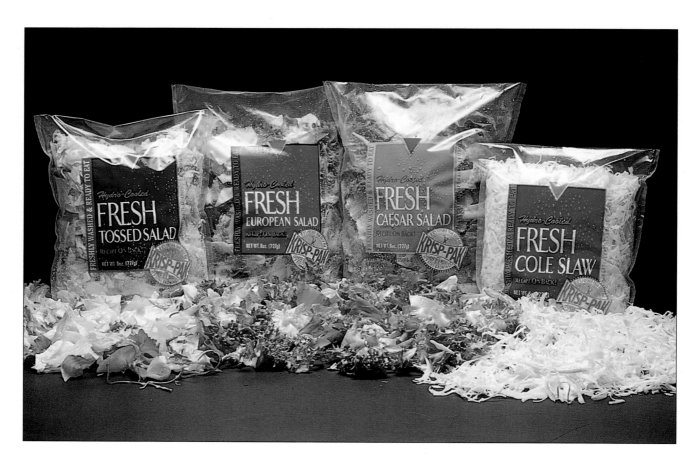

FRESH SALADS
HARRISBERGER CREATIVE,
VIRGINIA BEACH, VA

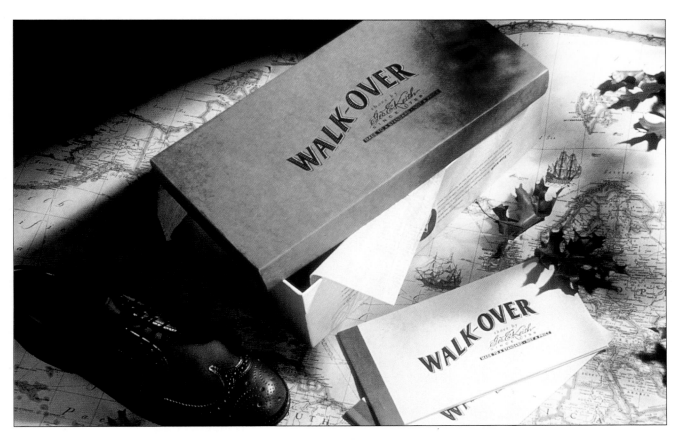

WALK OVER
DESIGN FIRM, STERLING DESIGN, NEW YORK, NY

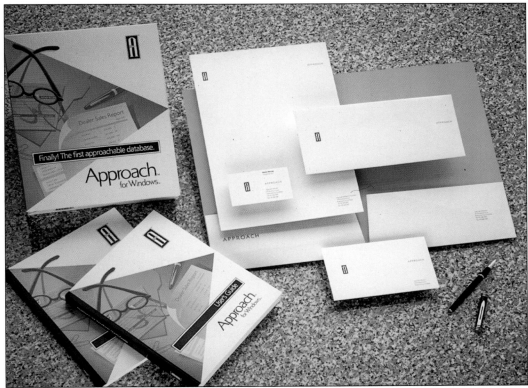

APPROACH SOFTWARE
DESIGN FIRM, PROFILE DESIGN, SAN FRANCISCO, CA

BRAHMA
**DESIGN FIRM, DIL
CONSULTANTS IN DESIGN,
SAO PAULO, BRAZIL**

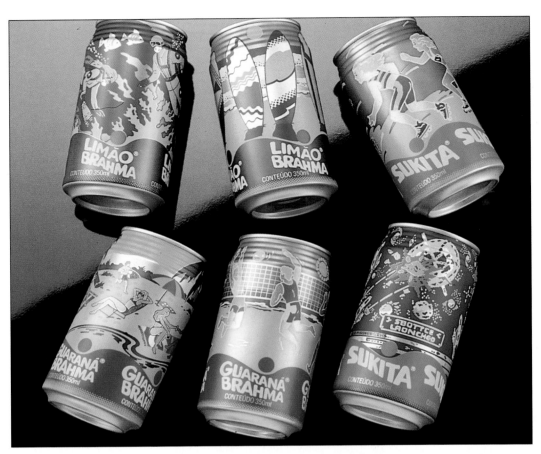

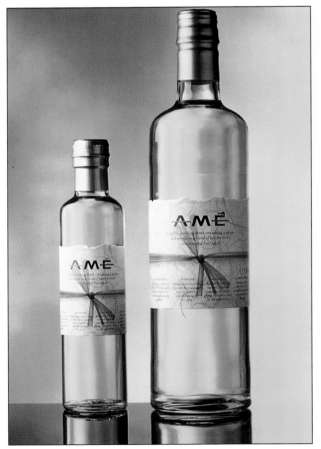

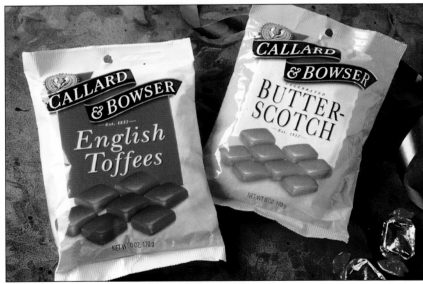

AME
**DESIGN FIRM, MILLER
SUTHERLAND, LONDON UK**

CALLARD & BOWSER
**DESIGN FIRM, STERLING DESIGN,
NEW YORK, NY**

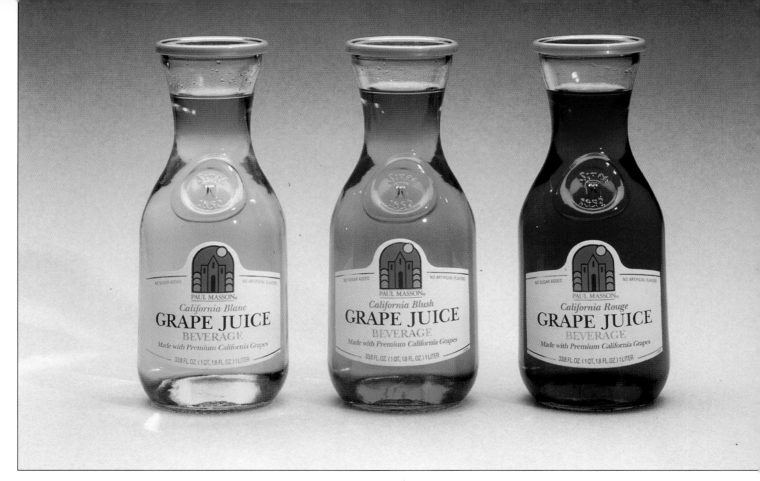

PAUL MASSON-GRAPE
JUICE
**DESIGN FIRM, D'ADDIARIO
DESIGN ASSOCIATES,
NEW YORK, NY**

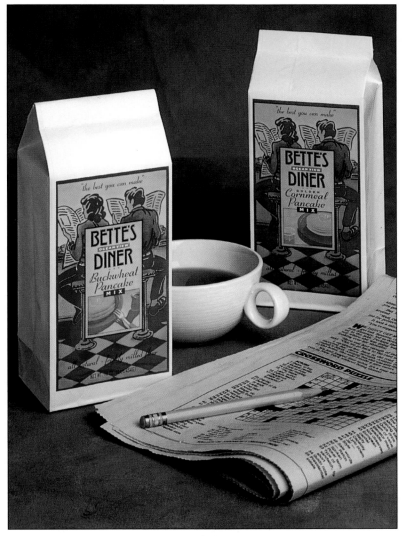

BETTE'S DINER
**DESIGN FIRM,
COLONNA FARRELL DESIGN,
ST. HELENA, CA**